chagall

chagall

Mario Bucci

Hamlyn

London New York Sydney Toronto

twentieth-century masters
General editors: H. L. Jaffé and A. Busignani

© Copyright in the text Sadea/Sansoni, Florence 1970
© Copyright in the illustrations ADAGP, Paris 1970
© Copyright this edition The Hamlyn Publishing Group Limited 1971
London · New York · Sydney · Toronto
Hamlyn House, Feltham, Middlesex, England
ISBN 0 600 31617 3

Filmset in England by Photoprint Plates, Rayleigh, Essex
Colour lithography: Zincotipia Moderna, Florence
Printed in Italy by: Industria Grafica L'Impronta, Scandicci, Florence
Bound in Italy by: S.p.A. Officine Grafiche Poligrafici il Resto del Carlino, Bologna

Distributed in the United States by Crown Publishers Inc.

contents

List of colour illustrations

List of black-and-white illustrations

The olive groves of Vence

I went to find him amid the olive trees in St Paul de Vence, on the fringes of one of the loveliest places in glowing Provence, near the sea but not beside it, set apart, rather, among undulating green slopes that lean down towards the coast. Down there is the sea, sensed as an atmosphere, a kind of vague presence, a bluer expanse beyond the rim of the hills. The hills themselves, woolly with pines, rise up behind the dark houses in those villages which seem to be carved straight out of the tobacco-coloured rock. In this part of France, a homely, domestic Eden, like some sort of modern Olympus, the latest gods of the 20th century have come to dwell in quiet – gods assuredly better organised and more comfortable than ancient Jove, Mars or Saturn ever were, but, like their Olympic forbears, secret and inaccessible.

A few miles away Picasso, the high-priest, is still delightedly discovering delicate girls with pink breasts, maddened bulls with arching black backs, old satyrs gazing with diabolical grimaces at the girls. A stone's throw away stands the white chapel in which Matisse traced the delicate outline of his angels as if on the side of a Greek urn, an ancient kylix with milk-coloured base. Léger and Braque have often been in these villages and stopped for long periods to fashion coloured ceramics or to decorate walls with frescoes.

Now at last, after a long wait and tiresome preambles I may talk more closely with, and get to know better, one of these grand old men of painting, Marc Chagall himself, who has been here for twenty years, withdrawn from the pressures of a busy life to a refuge which is safe and calm, where he may find peace in his last years.

The house is a simple white one: Mediterranean and anonymous. Set amid pines and olives, it is reached by an avenue which is steeped in the atmosphere of the country, with wild grasses and rich plants along its borders. Inside the house, everything is still white, like the outside, spotless, padded, with dark leather armchairs and books scattered everywhere, their covers cheery and colourful. The pale walls are blanched by the southern light which passes through the huge windows opening on to the countryside, which is visible beyond the transparent host of olives. His pictures, with their houses, carts, peasants, angels, goats, suns, snow, huts, and the bunches of flowers with red, blue, green and pink stripes, welcome us inside. Placed at intervals like this, seeming to enjoy the white surface behind them, as though they were mounted for an exhibition of fashionable architecture, the picture seems somewhat distant, almost out of place.

At last he comes in, skipping a little, a light man of small measurements with an extremely agile body still and delicate harmonious movements like a dancer; and above, a pointed Gothic face, a mask hovering over waving arms. A most mobile mask, but with a different mobility from that of his body, or at least not co-ordinated with it, rather like a marionette in a pup-

pet show. You feel those sharp, pointed eyes as clear as crystal gaze at you in deep scrutiny. Two oblique, extended slits separated by the hooked line of the nose, which is beaky, above a tight mouth forming a perfect V, which can crimp and fold into a sweet humane smile, or equally easily into a bitterly sceptical, almost diabolical criticism – a criticism and malignity which the eyes from time to time contradict through their extraordinary childlike candour. The eyes are those of a baby, amazed, curious, moved, amused, set in an ancient terracotta mask, almost Japanese, decorated with an entire alphabet of tiny lines scratched on it. And then there are the puffs of hair, the light, transparent white hair which form an aureole like spun sugar.

The words of the critic Efross who described him in 1918 sprang immediately into my mind: 'Chagall has the good face of a young faun, but when he is talking, the good-natured sweetness disappears like a mask, and then we think: the angles of Chagall's mouth are like over-sharp arrows, and his teeth are too keen, like those of a wild animal, and the blue-grey mildness of his eyes too often sparks with a riot of peculiar gleams.' That was Chagall in 1918, but he has not changed at all, and above all, has not aged one whit.

As for comparisons, the first name that comes to mind is that of Charlie Chaplin. Like him, Chagall moves with elegance, delicacy and with a clown's imagination; like him, he is small, light, well proportioned, persuasive and sweet, but at the same time as neat and sharp as a blade; but he is especially like him in being a refined Jew, a characteristic that speaks through his entire persona and in all his movements. He regards me closely, as I do him, while the photographer who is with me regards both of us; and he enjoys himself. The photographer and I look delightedly at his hands, those restless hands fluttering like butterflies' wings, ever engaged in a language of gesture to match that of our voices, like a commentary or a counterpoint which turns our minds to dancing and music. Most of all, he is an actor, a peerless mimic, just like Charlot himself; moreover he is Russian, oriental, with an infinite variety of meaningful gestures and expressions and with a talent for mimicry which is so histrionic as to seem almost magical.

I stood looking at the *Cattle Dealer*, the violinists, clocks and goats, all born in the heroic years between 1912 and 1923 within the filthy walls of a Paris studio – in the confusion of a room in the Ruche, amid paints, stools, tables, broiled pilchards, crusts of aniseed bread and all the bric-a-brac of the life of that time. Such was the chaotic scene of the studio where the Russian exile was laboriously establishing his place in the West, finding comfort in the company of poets, longing to know the world, yet frightened by it.

The world of Vitebsk

Chagall himself describes the early months in the capital, and the paintings of 1910 in his book *My Life*. He writes, with the enthusiasm of a young neophyte: 'I found my masters in the city, at every step, in every event. I found them among the sellers at the weekly open-air markets, among the waiters in cafés, the house-keepers, peasants and labourers. Around them wafted that extraordinary light of freedom that I had never seen elsewhere.' In his studio in the Ruche, with Soutine, Modigliani, Archipenko and Léger, who lived there at the same period before the First World War, he began to fashion his own world, at last getting rid of the complexes that had haunted him from childhood and that he had brought from his own village in his native Russia.

He was born on July 7, 1871, son of an ordinary labourer, 'in a little house near the street that leads straight to the prison on the outskirts of Vitebsk . . . where the poor Jews lived,' as he writes himself. His father was taciturn, shy, mild and full of sadness. His mother was, by contrast, inexhaustible, energetic, full of life. His father worked as a herring dealer, a hard job that wore him out; his mother kept on the move, took care of everything, organised the complicated daily life of their family of nine sons, of which Marc was the firstborn. He lived all his early years in one of the 7,000 wooden houses of which the village was composed, set beside the meeting of the rivers Vitsba and Dvina. The only monumental element in the little town-

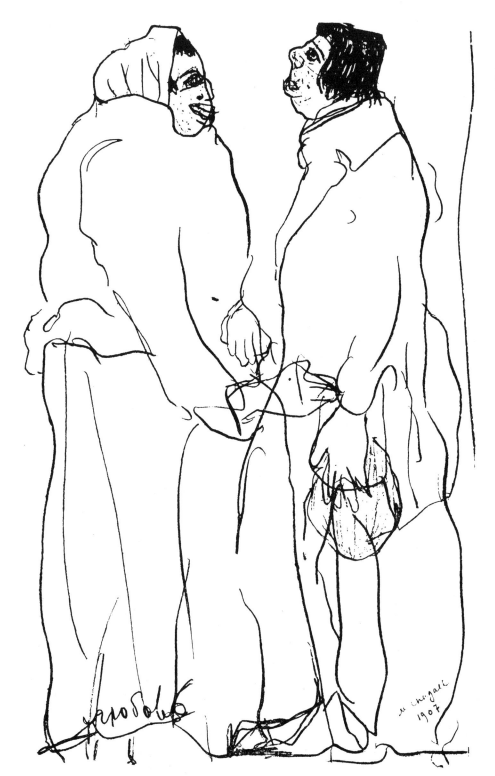

1 *Love*
1907, pencil drawing on paper
$11\frac{7}{16} \times 7\frac{1}{2}$ in (29 × 19 cm)
private collection,
France

ship was provided by its churches, of which there were about thirty. When his father managed to buy a larger house, in stone this time, with little wooden verandas giving on to a rear courtyard, Marc went to live just beside one of these churches. It was built entirely of wood, probably in the 17th century. This was his world, not merely during the early years in Russia, but for ever. He took it away with him to Paris, Berlin, America, the Côte d'Azur and even to Vence in his last years. This is the seam from which all his scenes are threaded, a conglomeration of churches, fences, stalls and wood roofs '. . . of synagogues as plain and perpetual as the buildings in the frescoes of Giotto'. Behind the house in Vitebsk, in a yard separate from the courtyard, hens stalked, cats slunk along every roof. Behind wooden railings, in low wooden houses, worked the craftsmen. Above this segment of the globe, compounded of houses, yards, little hills and churches, shone the stars that were to be his companions throughout his life. 'They are my stars, sweet stars. They accompanied me to school and waited in the street

till I came back.' One cannot understand Chagall unless one enters fully into the poetic aura of his world, his own village and his first loves.

His childhood world has never left him, as he says himself: 'Around me Jews of every type come and go, Jews old and young turn and return incessantly, or trot good-humouredly by.' He began to draw all he saw around him from the earliest years of his childhood in portraits of his family, his aunts, neighbours and friends. These are affectionate, sunny caricatures of a world he loved and loves the more the further away he is from it, for like all poets he lives by nostalgia and imagination. And thus his own domestic setting becomes more real the further he has to dig inside himself, to the depths of his nostalgia, to find it: in Paris, Berlin, America and in the tireless bright sunshine of the Côte d'Azur.

Like all the children of his age he attended the local Jewish elementary school. There he learned to preach by the hour, and better than anyone else, and this formed the basis of his profound religious feeling. He took violin and singing lessons, secretly hoping to become a great musician. He also went to a Russian-language school, a rare thing at that time for a Jew; thus he escaped the isolation of his own native tongue and broke away from the limited circle of his race to plunge into a wider, more comprehensive society. Of the subjects he studied his favourite was geometrical drawing. 'Squares, rectangles and triangles carried me off to fascinating wonderlands. During drawing lessons all I lacked was a throne. I was the focus of the classroom, the object of general contemplation, the example to everybody.' There is, in these words describing the Chagall of that time, the complete self portrait of the whole man, with his capacity to make poetry out of mathematical abstractions and his will to excel, his tenacious, hard-headed attentive determination to get somewhere. It was his revenge, to get rid of his complexes, to feel himself to be greater, not less, than others.

He had several motives for striving towards solidity, and a self-affirmation in life. In the first place he was Jewish, and anti-Semitism was very strong in Russia just then. He was also poor, if not actually indigent, and he had defective speech, with an insistent stutter of which he only managed to rid himself later. He was also of unusually small stature; and the little man, as has often been revealed (Napoleon or Chaplin) is tenacious, wilful, rebellious and of iron determination not merely to equal but to outstrip others.

My Fiancée in Black Gloves

At the end of school his mother took him to Pen, who ran a school of painting, announced by a sign hanging outside a little low house near the shops. Pen made him do exercises in portraiture and landscape taken from life. But Chagall's portraits of 1906 and 1907 immediately assumed a somewhat bizarre character, and his landscapes became somehow contorted, while the colours gave a new, deep interpretation to things as he saw them, a psychological interpretation which he sensed within the objects and people. One lovely drawing, *Love,* already reveals his fanciful style, Germanic in feeling, like George Grosz. In 1907 he went to St Petersburg, where he stayed for three years working and studying. This was his first plunge into a big city, but he frequently went back home and maintained contact with Vitebsk, and with his old and more recent friends there. One of his closest friends was Victor Mekler, who came from a rich, bourgeois family, to Chagall an entirely new and inviting sphere. It was in this very sphere that he later found the woman who was to be his wife and constant companion, Bella. In St Petersburg, with only a handful of roubles to live on, sleeping alongside others in dormitories divided by curtains, making do with a corner, he often fainted from lack of food, so he took to painting shop signs to earn his livelihood. 'How I enjoyed seeing my first shop signs,' he said in his book, 'swinging in the market over the entrance to a butcher's or greengrocer's shop. Nearby a pig or a hen would be scratching itself while heedless wind and rain splashed them with dirt.'

It was difficult for a Jew to get a residence permit, but he finally obtained one through the kind offices of a lawyer called Goldberg, who not only

Fig. 1

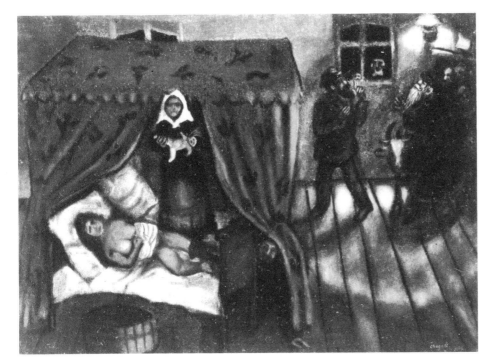

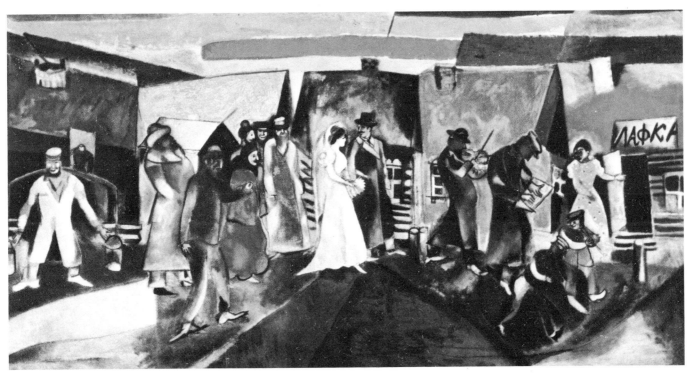

2 *The Birth*
1910, oil on canvas
$25\frac{9}{16} \times 35\frac{3}{16}$ in (65 × 89.5 cm)
property of the artist

3 *The Wedding*
1910, oil on canvas
$38\frac{9}{16} \times 74$ in (98 × 188 cm)
private collection,
Paris

put him up, but became the first collector of his work. Failing the entrance exam to the School of Fine Arts and Professions, and being ineligible for the Academy since he had no middle school diploma, he enrolled in the Imperial Society for the Encouragement of the Arts. He soon left this too conservative and academic establishment to entrol at another which was among the most liberal and modern then to be found in Russia. This school, which was directed by Elizabeth Svanseva, who had lived in Paris and returned to her country with very progressive ideas, was well able to provide and absorb the confused leaven of current novelty. For Chagall these were the first years of commissioned painting and research: he experimented with the nude, thanks to an intellectual girl student called Thea who posed for him. He would have been incapable of considering the nude at the class lessons of the Academy. He began to create atmospheres, little scenes charged with special symbols, with a series of couples and a more complex composition of characters within settings. In these one notices the special style of painters who preceded him: one sees his admiration for Gauguin, to whom he later dedicated a fine painting. It was soon after

his meeting with the impetuous, free and extrovert Thea, that he met by chance the person who was to be most important in his life, an inspiration, a counsellor, a woman, an ideal companion: Bella Rosenfeld.

Pl. 1 The meeting with Bella and the first summer of their wonderful friendship stimulated the first and most celebrated of the pictures dedicated to her: *My Fiancée in Black Gloves,* painted in 1909. What struck Chagall and strikes the spectator no less is her strange impatience; an inexplicable fascination is exerted by her pose, by the colours, and by that movement of her head. She looks as though she were turning away towards a distant horizon, as if beyond the meanness and compromise of everyday living. She was the right woman for Chagall.

Figs. 2, 3 1910 was the year of *Birth, Death* and *Wedding.* Even in his subjects one immediately notices his interest in the most important events in life, those which really represent a character, a focal point; and the way in which the subjects are realised is somewhere between the descriptive, the realistic and symbolic suggestion, an allusion which already reveals his own tastes and preferences. People have talked of the influence of Russian icons on these compositions, and it is an element worthy of mention since Chagall himself admits that 'my heart was glutted with icons'. This, then, explains the compositional feel, the jewel-like quality of the more succulent colours, as thick as enamel. But what must have impressed the painter most was how much of the chosen art of the icons was past and how much still alive in Russian popular art. The feeling for sketches in general, for the clear disposition of the folds of landscape and the distribution of the characters, like animated marionettes against a theatrical background, the grotesque spirit which underlines the gestures and faces of characters, is indeed the basic element of the Russian tradition, as is the splendour and hieratic majesty of the icons. Moreover in Russian literature we can find the same characteristics, particularly in the work of Gogol, who must have delighted Chagall so much that he made a commentary on his works with his engravings *Dead Souls.*

If there are clear indications that Russian popular art had some considerable influence on Chagall, it is also probable that the artist became aware, at about this time, of the art of antiquity and the content of museums generally. From these he was to derive more than a trace or suggestion, particularly from the Flemish painters of the 16th century, such as Bruegel, with his taste for the grotesque mixed with parable.

Paris, Cubism and more

After Svanseva, Chagall worked with Leon Bakst, who was summoned to Paris in 1910 to assist Diaghilev with his ballets. Chagall repeatedly begged to be allowed to follow his master and to help him realise the decor of the ballets. This approach proved negative, but once more a Maecenas came to the rescue, one Vinaver with whom Chagall was living, who gave him maintenance for a four-year period in Paris. Chagall was given the choice of Paris or Rome, but he knew even then where his destiny lay and that only Paris could become his own city.

In August 1910 he left Bella, Russia, the isbe, the synagogues, merchants, goats, stalls and fences, for Paris where he dreamed and saw all these things afresh. 'I have brought my things out of Russia: Paris has shed its light over them.' And the light of Paris, the '*lumière-liberté*' as he called it, was to shine for the moment through the Fauvists, Van Gogh, Matisse and Vlaminck with their single brush strokes which act like structures for a painting, but at the same time become its basic material. Chagall was seized with a joyous passion for pure colour; he abandoned drawing overlaid by colour and began to think in colour itself. Paintings like *Saturday, The Father,*

Fig. 4 *The Harvest,* are the 'things he brought out of Russia' over which the light of Paris and of the painting he saw there has spilled. Every picture during this period is a landmark, a recognisable stage in liberation and conquest. *The Bunch of Flowers* and *The Woman with a Bunch of Flowers* are the first of a series of essays that Chagall made as an interpretation of the feeling of flowers,

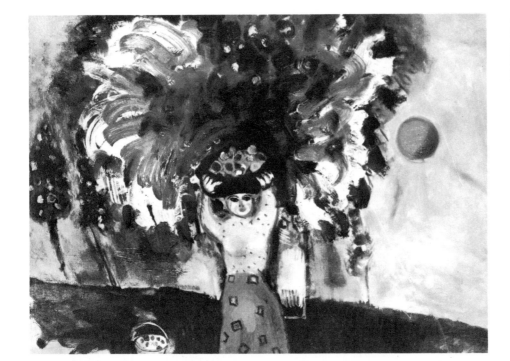

4 *The Harvest*
1910, oil on canvas
$33\frac{5}{8} \times 31\frac{7}{8}$ in (60 × 81 cm)
Perls Gallery,
New York

5 *The Studio*
1910, oil on canvas
$33\frac{5}{8} \times 30\frac{3}{4}$ in (60 × 73 cm)
property of the artist

a series that is still not finished, in which he constantly explores the possibilities of pure colour, with the substance of the drawing dissolving and becoming instead a phosphorescent, shining entity.

His discovery of the Fauves and their *lumière-liberté* struck him violently; in *L'Atelier (The Studio)*, a fundamental work of this first period in Paris, Fig. 5 we see the high peak of Fauvist influence on the artist: pure colour rolls around, enlivens, moves as if permeated by a mysterious internal breath which we shall see later in Soutine, whom Chagall seems almost to anticipate.

At the same time that he discovered a palette, a new fluidity and light, he discovered the city too. It is from these years, 1911-12, that his early visions of Paris came, with the Eiffel Tower looming over the Seine and its bridges, or the Eiffel Tower behind the huge wheel in a pleasure garden: an iron trellis, a Gothic steeple interpreted according to modern mechanics. These came to symbolise Paris in all the rest of his painting, just as the wooden shacks, the twisting alleys with wooden fences and the little onion-domed

6 *To my Wife*
1911, oil on canvas
$77\frac{3}{16} \times 45$ in (196 × 114.5 cm)
Art Museum,
Berne

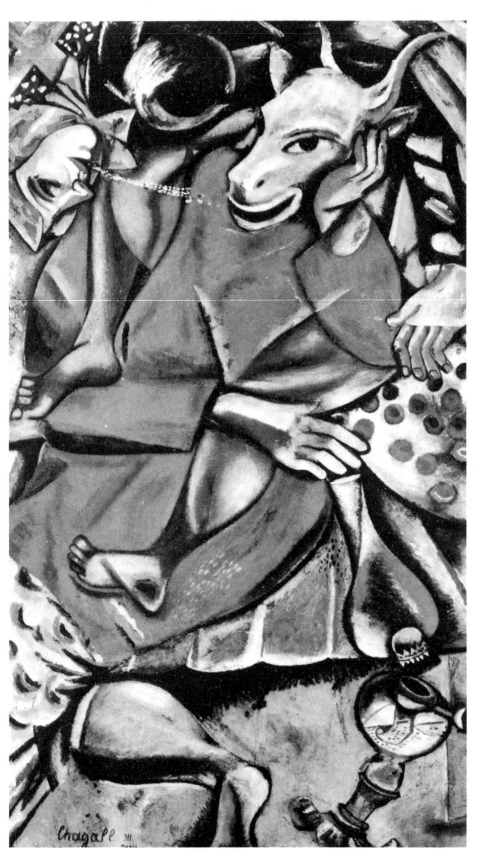

churches mean Russia. The Eiffel Tower, soaring off into the sky, is a most elegant symbol, and with it he identifies all his longing for flight, escape and spirituality. In the paintings executed towards the end of 1911 the painter's favourite subjects, the suburbs of Vitebsk, characters recalling the Jewish petit bourgeois, or the countryfolk, the organ-grinders and fiddlers – those little pictures which one might almost call the votive offerings by a Russian exile to his native land – acquire a new form, a more precise and influential structure and composition. The brush strokes are composed of commas, circles and well defined figures and geometrical forms. The rhythm is contained in dissectable and indissectable areas, all within the painting, so that even the shape of a fat cloud acquires rhythm and becomes part of

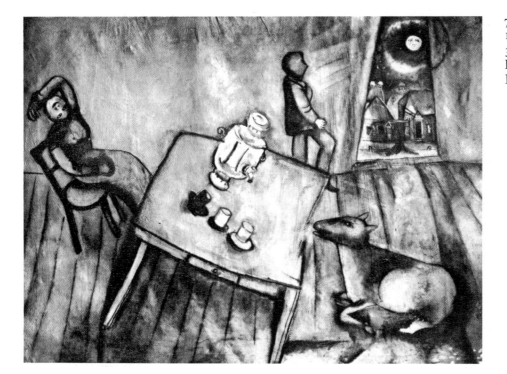

7 *The Yellow Room*
1911, oil on canvas
$33\frac{1}{16} \times 44\frac{1}{8}$ in (84 × 112 cm)
Dr Paul Hannig collection,
Basel

the rhythm of the whole. The street that rushes away uphill and the angle of a door or a chimney are now related, are contained within a scheme which acts as if geometricising or measuring reality according to a new scale.

This was the first meeting with Cubism, with which Chagall was to maintain a distinct connection, though only a superficial one limited to his persistent 'will to construct'. The Cubism of Picasso or Braque is a coherent transposition of the visual terms of reality into the visual terms of a picture, which builds a bridge between the two- and three-dimensional. Chagall, on the other hand, suggests a reality different from the visual one and merely makes use of Cubist techniques, borrows them to render the illogical, unbelievable element of existence, the miraculous and the other dimension, more sensitive, more immediate and almost more tactile within the boundless spaces of his memory.

All the same, it must not be denied that the Parisian environment stimulated him, and that the literary and artistic life of Montparnasse amid which he lived had a basic influence on him as it did on every other person of genius who lived in Paris between 1910 and 1914. Besides Robert Delaunay, whom he knew well and went to visit daily (he was the most admired of the painters working with the new Cubist ideas), the figures of the time included de la Fresnaye, Léger, Metzinger, Marcoussis, Segonzac. A picture such as *The Wedding,* is proof of his familiarity with this circle and his conscious awareness of the movement, but he adapted it to make his own world of the imagination clearer and stronger. One need only look at his clouds in the sky that have become coloured stripes '. . . applied like transparent banners, they seem to publicise a project of free colour in painting'. The folkloristic narrative element of *The Wedding* in 1909, still like a family sketch, has been poured out in the rarified intellectual atmosphere of Paris, and is no longer a representation but a symbol. Once the subject of weddings, so dear to the artist, had been purified, he took up that of the dead, with shades of colour that tend to abstraction, to an imaginative projection of feelings that end by pervading and dictating even the formal appearance of reality. The green of that sky is a background for the magical colour contrast of the houses, of the ghostlike characters who people the streets, the violinist who is transformed into a black cloud. In the foreground is the dead man, glimpsed between fluttering candles like a tragical expressionistic mask. In the late version of *The Birth* it is not the scene and its course of events, nor its details – or at least it is not so much this, the apparent subject matter – that counts, but the way in which the artist makes use of the Cubist

Fig. 3

break-up of forms as a language to portray the movement, tension, and excited throb of the whole household at the unusual event. Colour and geometry, scansion and rhythm are used to give restlessness and tingling dynamism to the whole scene.

There are other works charged with this new Cubist energy, especially still lifes, among which we should mention the *Still Life in Blue,* whose violent colours and clearly delineated rhythmical sections seem forerunners of the solutions Chagall was to employ with mastery much later on, towards 1960, in his stained glass. It is in these latest compositions and the ones that immediately followed that we see the start of that of the real and the imaginary, the mixture of inner and outer images, of symbol and reality, that form the artist's characteristic language. In 1911, after a preparatory phase of gouaches, we come to paintings like the fantastic, dreamlike Figs. 6, 7 *To my Wife* and *The Yellow Room.* The bounds of reality have lost their validity; or at least they have been refashioned in apparently illogical and irrational ways, at any rate if considered from the common view of the vigorous, logical syntax of reality. But what is basically logical or irrational? What, basically, is the very concept of reality, of reality as we know it? Chagall's reality may become a unified, logical, absolutely consistent reality only if we follow his personal syntax which is not 'rational'. His terms certainly seem to be common ones, but in the painter's inner eye they acquire an entirely particular suggestion, an evocative shape that is at once symbolic and emotive, a reasoning that is born of instinct and is coloured by the palette of imagination. Let us take the animals as examples. In Chagall's paintings numbers of domestic animals, both large and small, turn out, move, fly and stare. These cows, bulls, donkeys, horses, goats, hens and fish are the recollection of a lost happiness. And they become new, are imbued with a new quality and a fresh significance which overcomes reality and goes beyond it: they become symbols. Or, as has often been noted, they reappear as symbols just as they were in the strata of ancient civilisations long since buried: they lie deep in the subconscious of our race, they are archetypes. Like the masks of primitive peoples, that is to say, the faces more true than truth itself, they are the deepest-lying reality of our subconscious mind and of our dreams. They are not the obvious reality, that external one which is humanity's shell.

It should be made clear, however, that if there are Freudian connections here, they are entirely spontaneous and absolutely instinctive. Chagall was not in the least interested in Freud at that time, '... as far as I'm concerned, I've slept well enough without Freud' he was to say in 1944 when he was remembering the birth of this peculiar world of his. Thus, once it has been established that he was utterly ignorant of psychoanalytical research, we may comment that while psychoanalysis may help to interpret Chagall's work it has no place in its origin. The artist, as always, acts by intuition. Sometimes, as in this case, he reaches the same conclusions as the scientist who scrutinises and dissects reality, but by his own route. This is ancient symbolism intuitively rediscovered, such as we see in the graffiti, the grottoes, and the magic signs that are common to all the nations on earth. Animals acquire a new life, representing the zone of unthinking creation, while man features as rational and aware. That is why in the dreamlike *To my Wife* the bull's head expresses mad bestiality, primitive rational strength and the erotic instinct. He is the dominant sexual urge, as he originally was and always is in our subconscious, like Picasso's *Minotaur.* Saliva, or 'Devil's spit' shoots from the woman's mouth to that of the bull-man, like a splash of primordial vitality. And the whole picture is seized in this orgiastic, broken rhythm, syncopated as if, 'panting for breath', the pulse of a carnal energy had formed the predominant structure, from the stretcher to the whole picture. Red, the colour of sex and freedom, screams across almost half the picture. Even in *The Yellow Room* colour permeates the whole dynamic of the painting and beats in its organism like blood through the arteries and veins. It is the colour that dictates the form, not the reverse, as Chagall in

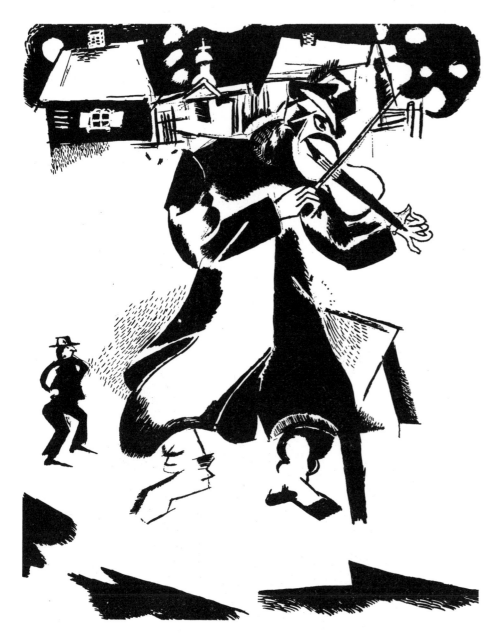

8 *The Violinist*
1911, black ink on paper
$11\frac{7}{16} \times 9\frac{1}{8}$ in (29 × 23.5 cm)
private collection,
Zürich

fact tells us himself: 'We must not begin with symbols but arrive at them.' Colour, then, is the basic emotion, one might almost say the reason and condition of the artist's act of love in relation to a work of art, a kind of intellectual erection, without which procreation and the birth of a symbol-creature would not be feasible.

To Russia, Asses and Others

In the winter of 1911-12 Chagall moved from his old lodging in the Impasse du Maine to his first big, proper studio inside the famous Ruche, the original warren in which lived Léger, Laurens, Archipenko, Sterenberg, Soffici, Kogan and Modigliani. A poet was living there too, Blaise Cendrars, and the meeting of the poet with the painter was certainly one of the most fruitful and stimulating for both of them. In his *Poemes élastiques* Cendrars constantly refers to the new world Chagall was painting in his first absolute masterpieces. Inspired partly by the experience of having a large area at his disposal for the first time, he painted during the night on cheap canvases bought at the flea-market, on damask napkins, old sheets and remnants of silk – *To Russia, Asses, and Others, The Violinist, Homage to Apollinaire.* Chagall's other great poetic encounter of this period, besides that with Cendrars, was with Apollinaire: 'Apollinaire sits down, blushes, swells. He smiles and murmurs: supernatural. The day afterwards I receive a letter, a poem dedicated to me: Rodztag.' The poet was captivated by the painter's new, free language, and the painter had at last found someone who could say in words what he was saying in images. His stupendous allegories which many, too many, considered abstruse and morbid had found their

Pls. 2, 3

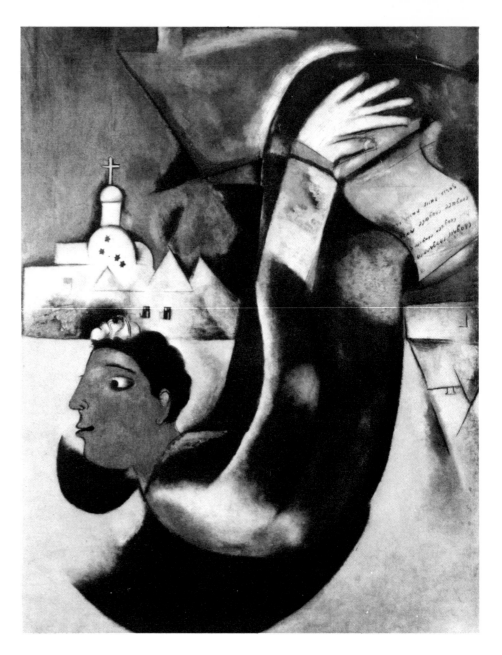

first real lovers to comment on them – the art critics who followed later were to understand them much less fully. It was poet's painting, so it was right that it was the poets and not the critics who first felt its enchantment, its magical sense of allusion. In these most recent works the motivating idea is more clearly contained within a linear plan, as if to disclose a more deliberate elaboration of the instinctive image, which the painter now means to put into some sort of order. This happens in the case of the houses in *To Russia, Asses, and Others,* to the domed churches, the cow and the peasant woman who floats through the air with her head separated from her body, split up with diagonals as if a grid had divided the composition into various sectors. This process is even clearer in *Homage to Apollinaire,* where the free motive of Adam and Eve appears, with the lower parts of their bodies still joined; they are the characters who find their justification in the birth of original sin. They do not play any part in the surrounding scene but renounce all reference to paradise on earth in order to act as a human hand, the needle of a compass in a circular geometrical form which alludes to the concept of space and time. The same circle returns frequently as a *leitmotif* throughout Chagall's work, the cornice or rayed background to this Adam in which all the pairs of lovers of his future paintings are portrayed definitively.

Fig. 9 At about this time the violent apparition, like a thunderbolt across the picture, of *The Holy Coachman,* is the start of a whole series of angel-demons, of characters who fly across the secret, magical spaces of his paint-

Fig. 10 ings. In the one called *Me and my Village, 1911,* Chagall reveals a new

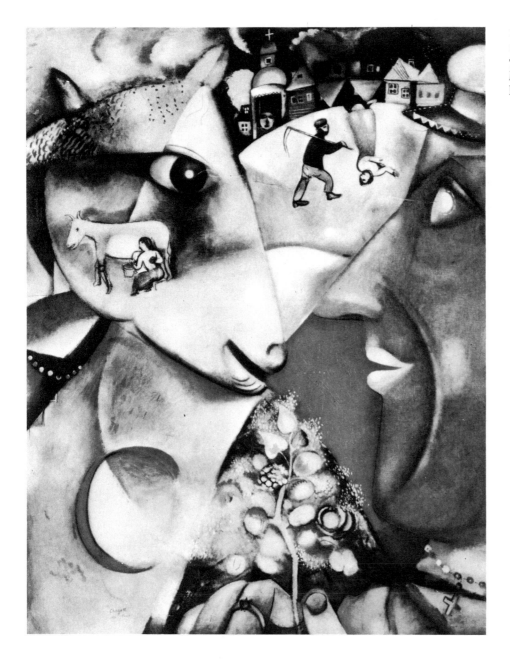

10 *Me and my Village*
1911, oil on canvas
$75\frac{3}{16} \times 59\frac{1}{8}$ in (191.2 \times 150.5 cm)
Museum of Modern Art,
New York

internal balance: a balance that starts from a geometric division of the sur-face and inserts within the rhythm of this element shapes that may become figures, but which at the same time serve as a landscape background to other figures, relating a story which is told by the large form of the whole work taken together. The relationship between form and motive is now so close that the geometric form, the composition and the figuration have become one thing. No longer does the figure stand out against a neutral background, or a colour that serves as a general backing. The two heads of the man and the cow are the basic part of the painting, with the milking depicted in the cow's jaw and the hill with the trees in the segment at the bottom.

At this point in his life Chagall felt that he had found a language, a range of signs suited to his own world. This new-found awareness of himself is revealed in the *Self Portrait with Seven Fingers*. In this picture items and details of reality are very clearly portrayed: the almond eyes, the beaked nose bridg-ing strongly from the forehead, the mouth tense and as if shut for the effort, and a crown of curls. But the shadings and uncertainty, the blurring of the visible features in the preparatory drawing, or rather of those that are elements of reality, these all give way to the portrait of the volitive man, aware and not vulnerable. They are the portrait of the idea of himself. This is the start of a great series of portraits that Chagall was to make of himself; and of others that he was to make of his friend, Mazin, who

Golgotha

Fig. 11

19

Fig. 12

By 1912, with the new music of *Golgotha,* a music derived from an older drawing of his Russian period which was in turn inspired by the traditional painting of icons, Chagall confirms the direction of the route he has embarked upon. 'To be exact, there was no cross there, only an azure baby in the air. The cross was not so interesting . . .' And the picture went to the Walden exhibition in 1913 with the title 'Dedicated to Christ' concealed below the apparent Cubism of its surface because of the rhythm of its geometric forms, and, like the Cubist paintings, was only partially understood and by only a few people. His paintings only amazed people with their 'something infantile, something below the known limits of the conscious, something instinctive, uncontrolled and spontaneous,' as Tugendhold remarked in his impressions of the Salon d'Automne.

The Chagall of *The Poet* is tinged with Futurism as well as Cubism. One can also discern the influence of the Léger of that period in some of the pictures, especially the *Women in Blue* of 1912. The difference is that in Chagall the movement begins from the figure, and is not a rhythmical movement embracing the whole picture, since the figure itself is the main point of the artist's interest. Besides, there is also the movement of colour, which is generated by the colour itself: the *Women in Blue* seems to have been scanned in rhythms of colour, or viewed through a kaleidoscope, a

11 *The Poet or Half Past Three*
1911, oil on canvas
$77\frac{9}{16} \times 57\frac{1}{2}$ in (197 × 146 cm)
Museum of Art,
Philadelphia

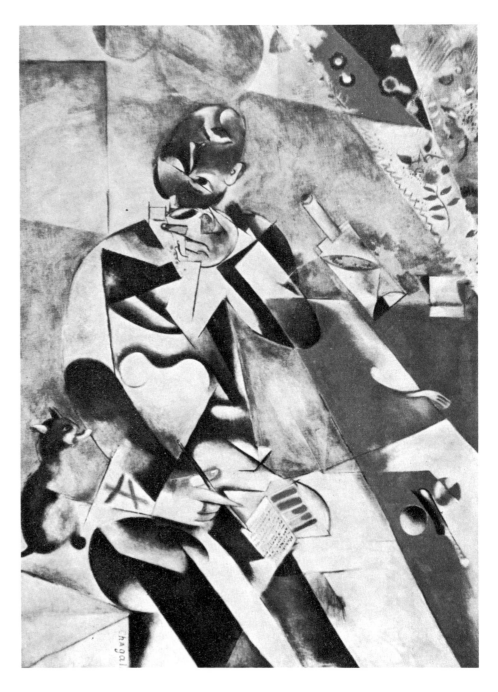

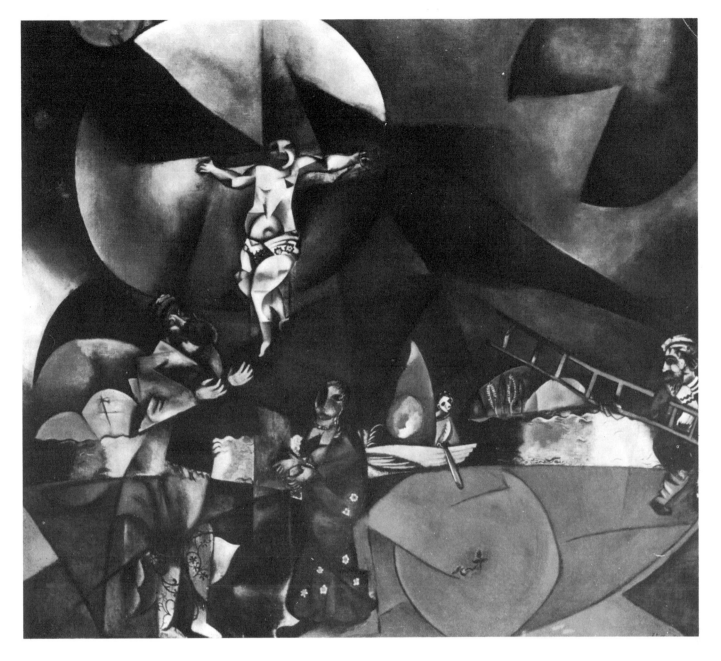

vision of that 'singular, restless spirit' as Apollinaire said, just as Adam and Eve were. The artist's secret, his equilibrium, is achieved by the harmony of a new mobility with an earlier established immobility. This can be seen, in the *Homage to Apollinaire* and in *The Horse and Cattle Dealer,* as a fundamental keystone of the artist's work, which Meyer describes in the following lovely word-images: '. . . freed of all earthly weight the old nag gets up and flies through the air, and stops at the same time, caught up in a legend, motionless in eternity, like the figures painted on the walls of ice-age caverns and, like them, caught in that indefinable time in which the split second and eternity are fused.' As precise as a ballet, *The Horse and Cattle Dealer* is the shining example of the magic fixing of changing beings in the foreordained immanent immobility of space, which is to be found in all the pictures of 1912-14. These all figure the acrobats, characters dear to the poetic world of Chagall, as they were to his contemporary Picasso, but for different reasons and seen in a quite different mood. The idea of flight which the artist so loved can be perfectly joined with acrobats, with jugglers as animal-symbols, which then represent visually a dance, or a flight which dream objects contain within themselves. In addition to the ideas of flight and acrobats another point of reference appeared in Chagall's work at this time, and has remained ever since, namely the Bible.

For Chagall the Jew the Bible is the classical element, just as Greek sculptures, capitals and friezes are for De Chirico the metaphysical. Chagall's

12 *Golgotha*
1912, oil on canvas
$68\frac{1}{2} \times 75\frac{3}{16}$ in (174×191 cm)
Museum of Modern Art,
New York

Pl. 4-5

14 *The Acrobat*
1913, pen drawing on paper
$4\frac{3}{4} \times 7\frac{1}{2}$ in (12 × 19 cm)
Zajde collection,
Paris

Fig. 15

world of fable, the myth that feeds and underlies history, is the Old and New Testament. 'At that time I wanted to measure myself against tradition and make fast my connections with it,' he was to say. His *Resurrection of Lazarus* has the same simplicity, the same frank amazement, the same emotional truth as the paintings in the catacombs, the Early Christian frescoes. Clearly he had to turn back to his origins, to become pure again; and in this sense Vitebsk, the Bible, the animals of his imagination and the paintings of the catacombs all belonged to the same world. Chagall's origins also include Russian icons, the miniatures from ancient church text books, where the iconography is simple, expanded in the rhythm and brilliant, shining colours of the paint. The connection can be seen in *The Resurrection,* or in *Maternity* or *The Madonna*.

All the work of his first years in Paris is backward-looking; he was recollecting his village and his country, but the recollection was filtered through new experiences, Cubist, Impressionist and Surrealist.

In the spring of 1912 Chagall exhibited for the first time at the Indépendants, and in 1913 he was there again with *The Birth* and *Adam and Eve*. But he was unable to sell anything till the end of 1914. His first attempt at a compromise was in a contract with a dealer, an agreement to hand over some small paintings in return for a fixed payment of 250 francs a month. But he did not get far with it, and the dealer only received paintings once. Finally, in May 1914, he set off on his second great adventure, for Berlin. In fact he stayed in Berlin till 1923. The occasion of his trip was an exhibition at the Sturm Gallery, his first important one-man show, with forty paintings, watercolours and gouaches that he had done in Paris. The invitation to Berlin had been engineered by the dealer-critic Walden. Chagall set out with his heart full of high hopes and his bag full of work. He did not know then that he would stay away from his beloved Paris for years, nor that war was at the gates, still less that he would return to Russia for his sister's wedding

To Berlin and in Russia

15 *Maternity*
1913, oil on canvas
76 × 45¼ in (194 × 115 cm)
Stedelijk Museum,
Amsterdam

and again meet, and soon marry, Bella Rosenfeld. He went away without realising that Berlin, not Paris, was to launch him on his road, provide him with his first market; it was that city which not only understood him but bought his important works.

In Berlin he devoted himself to studying pictures in the museums, as he had recently done in the Louvre, aligning himself with the artists that most interested him either for their imaginative worlds or for their substance. It is relevant to note who his favourites were. In the charmed circle of the adored one finds the greatest variety of names, representing the most diverse tendencies both ancient and modern. We find recent names, naturally including Cézanne, whose attitude to composition he admired as well as his solid structure, and Van Gogh whom he chose for his palette and expressionist distortion. But we also find the 'primitives', Cimabue and Giotto: the former he admired for his sharp accurate drawing and dramatic Byzantine expressionism, which he connected with the icons; Giotto for his construction and pre-Cubist instinct. From the painters of the 15th century he chose Fouquet for his polish and rhythm; among northern painters, Bruegel, in whose grotesques, free imagination and tendency towards moralising metaphor he found echoes of himself. He admired the colour impasto of the 16th century, and the texture, as the Impressionists had done, especially the Venetians where certain rare shades of violet, malachite greens and intense chalk whites aroused him. In 18th-century artists such as Chardin what most struck him was the poetry and the freshness of the palette with its gentle pastel shades. From every source Chagall sought to enrich his imagination and the sense of colour which constantly expanded within him like a 'colour of the spirit', or a reflection of a state of mind. This explains his greens, reds, acid yellows and pasty whites. It was he himself who wrote so poetically about the portrait of the preacher Slusk: '. . . I had the feeling that the old man was green: perhaps a shadow from my heart was falling across him.' *The Birthday,* painted at a later date, when he had already returned from Germany to Russia and met Bella, is imbued with a lyrical emanation whose origin Bella herself tells us about. She had gone to visit him, taking some flowers as a present for his birthday when suddenly . . . 'You threw yourself at the canvas which shook in your hands, snatched up a brush and pressed colours from the tubes: red, blue, white and black. You dragged me into the torrent of colours. Suddenly you lifted me up off the floor and gave a little kick with your foot as though the room were too narrow for you. You bounded up and flew towards the ceiling . . . we got to the window and wanted to go through it. From the window an airy cloud called out to us and a piece of blue sky . . . we fly over fields of flowers and wooden houses with the shutters closed, over countryside and churches . . .' One of Chagall's flights is perfectly captured at its birth, one of those flights that only become absolutely normal when considered as poetry.

The October Revolution

Chagall was in Russia when war broke out. As he could no longer put off military service, he enlisted in a company at St Petersburg which was responsible for organisation of materials and military administration. It was then that he got to know Pasternak and Mayakowsky. Meanwhile his first show in his own country opened in Moscow, the critic Efross giving it most favourable reviews. He was getting closer and closer to all that had to do with his origins, his race; in fact he found Hebrew script itself extremely beautiful to look at. And it is clear that this was to have a great influence on the very structure of his figures and the music of his compositions, which sometimes seem to be adapted to the rhythm of Cyrillic script. This love of the actual characters of the scriptures is fundamental to his black and white illustrations and the distinguished engravings he was to make. The latter are characterised by a precise feel for the printed page and the position that the illustration must have on it, like the miniature in some ancient codex.

However, it was above all the political events that formed the real back-

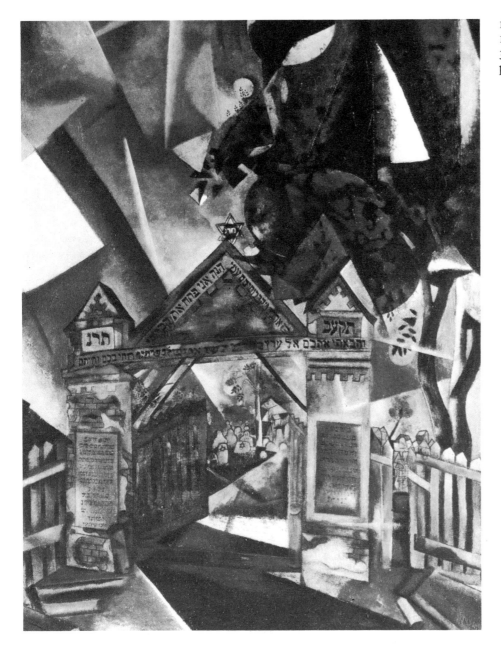

16 *The Cemetery Gate*
1917, oil on canvas
$34\frac{1}{4} \times 27$ in (87×68.5 cm)
private collection

ground to Chagall's pictures in 1916 and 1917. The portrait of Bella has the austere grandeur of an icon, while the blaze of blue in *The Cemetery Gate*, with its fantastic, difficult harmony of greens and blues, is deeply religious in feeling and expresses the seriousness of the time with its political up–heavals. He at last found in Russia, at least for the first months of his stay, full recognition of his own rights as an exponent of avant-garde ideas. He was in his own country, in fact, when the October Revolution took place, and he realised its importance immediately. His involvement was an active one: he was one of its prime movers and encouragers until the crisis that quickly followed. In 1918 he was made Commissioner for Art in his home town of Vitebsk. He took care of various exhibitions, a school of painting, and of a museum of art which opened in the city itself. In 1919, on the first anniversary of the Revolution, a significant event took place: Chagall was officially made responsible for decorating the city. He conceived and executed some giant standards, triumphal arches, and flying figures to be placed at various main points in the city. One can hardly imagine the impression– or rather the shock–felt by the staunch traditional citizens when they saw what their fellow countryman and whole-hearted revolutionary Chagall had achieved with his flying figures set over the wood shacks and tutelary angels singing hymns for the Communist party. Only a few months passed before criticisms began to be aired, which soon became too harsh to permit any possibility of dialogue between the artist and the revolutionaries who remained petit bourgeois in their tastes.

Fig. 16

25

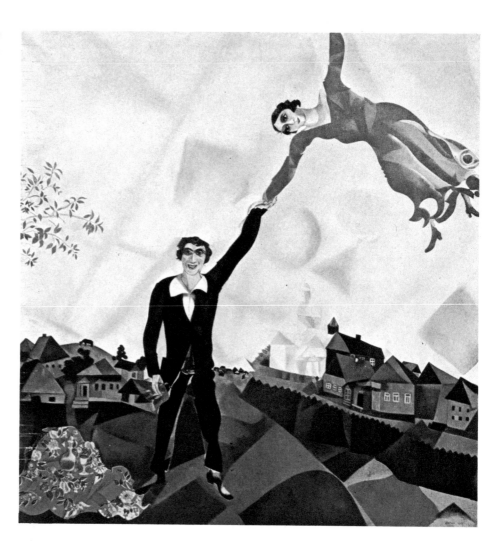

17 *The Walk*
1917–18, oil on canvas
67 × 64⅜ in (170 × 163.5 cm)
Russian National Museum,
Leningrad

Chagall was forced to defend both himself and the liberty of the artist to express his ideas. 'Art today, like that of tomorrow, requires no messages,' he wrote in 1919. 'Art that is truly proletarian must be that which makes a simple, well judged and total break with everything that may be described as literature . . . Proletarian art is not an art for proletarians, nor even an art by proletarians . . . it is the art of the proletarian painter, and is quite different from that of the bourgeois who strives to satisfy the taste of the people: the proletarian painter never stops fighting against routine. He draws the crowd with him . . . An art in which two and two make four, which is currently the most widespread and most favoured, is unworthy of our time.' This really is the 'credo' of Chagall and the one wise, dignified answer to the wretched and general lack of understanding which greeted his innovations. He had founded an Academy of Painting in Vitebsk, but his own foundation slipped through his hands, and then turned its back on him. In 1920 he left Vitebsk for Moscow, as a result of the insuperable differences that had arisen between him and the supreme head Malevic, who had himself been invited by Chagall to hold painting lessons in the Academy.

The artist's struggle continued in Moscow: his argument grew more forceful and he gave expression to it principally by humour, a subtle, Jewish type of humour, which is really 'argument by the right instance against the wrong'. He stayed in Moscow from 1920 until 1921, which he found a trying experience. He sold no paintings, but gave lessons at an establishment for small children in return for a derisory fee, which had been settled by Kandinsky, Rodschenko and his erstwhile friend Malevic. The school, and his close, intense relationship with the boys and their art proved to be his one consolation. He would stand enraptured in front of their drawings, sketches and inspired doodles. However, such a life could not satisfy him for long, and he left Malachovska and returned to Berlin. Marxist politics required men of technical skill and Chagall was definitely

not the man best suited to social Communist realities. The most important element of his visit to Russia was, as we shall see, his contact with theatrical circles, the creation of decor and costumes for shows, his official entrée into a magic world which perfectly matched his own inclination towards the spectacular and imaginative.

He went back to Germany because life in his own country had become impossible for him, but this second departure was to make a more marked impact on his feelings than the first. In Berlin he found once more his group of faithful friends, but also had a few unpleasant surprises. He discovered that he had made a deep impression on the art of Western Europe and that he was now called the 'father of Expressionism', his most passionate admirer being Max Ernst. But at the same time he became involved in difficult legal battles: there were complications and altercations with Walden and his wife over the paintings he had left in Berlin before his long stay in Russia. These had mostly disappeared, either lost or sold, and Chagall had received no payment. Perhaps this was one symptom of the chaos in which the German capital found itself at every level of society in 1922. Chagall himself sums up the situation: 'Everyone wanted to buy or sell pictures when a bread roll cost a couple of millions . . . in the restaurants and wine parlours

18 *The Man with the Lamp*
1921, black ink drawing
with a print
from some material
$29\frac{11}{16} \times 12\frac{5}{8}$ in (45 × 32 cm)
private collection,
France

in Motzstrasse you could find more Russian colonels and generals than in a garrison of Czarist Russia, but with the difference that in Berlin they were working as cooks and dishwashers. And in all my life I have never seen so many rabbis in the odour of sanctity . . .'

In 1923 he abandoned the crowded, chaotic atmosphere of Berlin for Paris. But here too there was no lack of shocks: shocks which were especially grievous to him in that they involved the loss or sale of very many of his early works, including some of the best from his first stay in Paris. The subjects he loved, however, which were ever present in his mind and imagination, soon came out in a second version, as though he wished to create a constant series of *leitmotifs* which could never run dry though the first, original expression of them was lost.

Apart from this initial setback, his return to the French capital was triumphant in every way. This was his second home. He was already a celebrated artist; he was given room and means to work in Eugène Zak's studio in the Avenue d'Orleans, where he settled. Propositions and invitations of all kinds were extended to him and his presence was requested at all the most important exhibitions. He was asked to help with book illustrations, one of the most important of these being the invitation by the editor Vollard to illustrate Gogol's *Dead Souls*. This he undertook, in a series of 107 particularly fine engravings, all exuding an authentically free, bizarre spirit as natural to him as to the author, his compatriot. These works constitute a true translation of the story into visual terms. He found his own Russia once more in Gogol's pages, 'without folklore and without sentimentality, but filled with a vivid, human reality which inspired him with the images of his own poetic version,' as Meyer said. They are the fruit of the Russian years tempered by time: they were born of his love for his own people, which is expressed in the detail of each feature. They have an almost medieval character, such as we find in the great Russian cinema directors, especially Eisenstein in *Alexander Nevsky*.

The Vollard Circus

During this period there was also a move in Paris towards codifying Surrealism (the Manifesto is from 1924), and Ernst, Eluard and Gala went to see Chagall in his studio in an attempt to recruit him as a member of the movement. However, although in sympathy, Chagall found the Surrealist movement too cerebral, derived from an intellectualism which he, as a good son of the people, hated. It was too programmed, too literary. The Surrealists had their answer to his gentle but firm rebuff by endowing Chagall with the epithet 'mystical', using it, however, in its negative sense. He opened

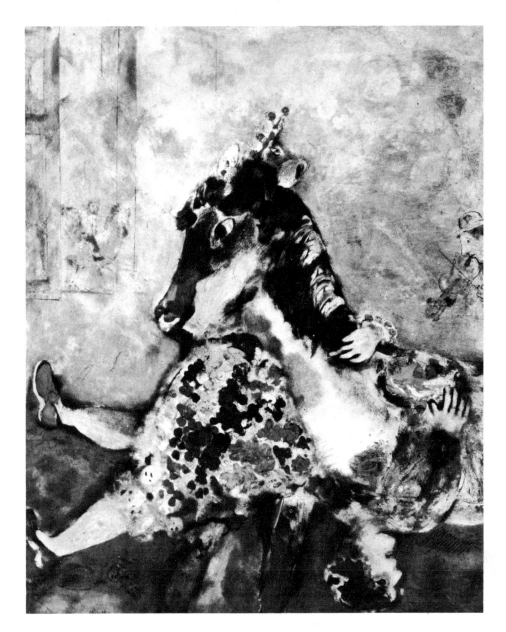

20 *The Woman Horse-Rider*
1927, oil on canvas
$39\frac{3}{8} \times 31\frac{1}{2}$ in (100 × 81 cm)
Narodny Gallery,
Prague

his arms wide and murmured disconsolately, with that trace of satirical and genuine amazement which were forever giving him away: 'For them everything is mystical.'

The new versions of the lost paintings and the new subjects taken from the world of his childhood in Russia emerged in different forms on each occasion and with, above all, different colour. This time it was the French countryside and the liberating light of Paris that overlaid his memory. The landscape of France and the Breton sea where he often went give a different modulation to his recollection. His imaginative motifs and spirit may have been the same and were to remain so for a further forty years of painting; but they emerge differently through different processes of maturity, through a kind of internal transformation that constantly develops in this kind of spiritual research into the past. Even the recurring theme of the window with a landscape which he turned to repeatedly at this time, has a logical explanation of its own. The window stands for the boundary between inside and outside. It is an opening on the world through which the eye can see a great distance. But it can also be closed, so that we can come back and look at ourselves inside. There is a spatial precipice into which we might leap, as though on to a trampoline, but the space must not be without limit or frame. The well defined boundary of the window permits us to return on our rebound from the trampoline as a boomerang returns to its point of departure.

These are the years of the series of landscapes, flowers and radiant country-side imbued with a Russian atmosphere. At the same time they are the start of a new cycle in the series of gouaches known as the 'Vollard Circus'. It was the famous editor himself who invited Chagall into a box in a theatre where a circus was performing; every evening editor and artist came together to make notes and trace lines on blocks of paper. The circus excited Chagall: it represented freedom of association, in that its characters, the clowns, for example, combine imagination, vital energy and movement. They are ideal characters. What could be more Chagallian than acrobats flying around, when the painter had from his earliest youth depicted angels zooming into his pictures or hung on an idealised trapeze? And in this series painted between 1927 and 1929-30 we find him doubling up his images more and more to give an unreal dynamism to his pictures. His favourite subjects, such as flowers, fiddles, goats, huts, cows and fish, no longer move on the canvas as if tied down to a rational plan, they pitch and toss. At last they are freed, these wandering articles of his poetic faith: they have exactly the same value as the Hebraic letters in a piece of scripture or scattered over a background, catapulted into space. These letters actually make up his own name, Chagall, all different yet linked to a single concept which is at once his aesthetic and his composition. CHAGALL over architecture; CHAGALL as a decorative frieze. These free symbols, these image-words, are closely connected with the Cubist experiments and the poets Supervielle, Eluard and René Schwob. At this time he made the acquaintance of Jacques Maritain and his wife Raissa, who were to write about him, and began to write *My Life* in French, assisted by Bella and making use of the notes he had taken during the years of his youth in Russia.

Journey to Palestine

In 1930 Chagall went to live at the Villa Montmorency near the Porte d'Auteuil in a house where a woman friend of Victor Hugo's had lived. In winter, together with his inseparable companion Bella, he would go for long spells to Switzerland where he rediscovered in the snow the atmosphere of Russia, the fat, soft silence of his homeland. The primordial calm of the mountains, too, with their fir trees and mountain pines, brought back memories of his own country. His pictures are no longer fusions: colour and design really are only one thing, and it is the brush stroke itself that becomes figurative or the figure that expands to form a background. In these pictures, as in his dreams, there is no dividing line between figure and setting. Colour stands as the amalgam, the result of a magical internal chemistry according to a style and technique that form the basis for the development of a whole new phase. Everything comes into being by enchantment, and the lines of fantasy and perception of the world are fused into one.

For the first time we see clocks appearing in the timeless skies. The grand-father clock, looming heavily against a distant landscape, either by itself or accompanied by other symbols, is a fragment of his childhood. It is depicted in an elegant 19th-century case as it was seen in the inner eye of the painter who beheld it again on the wall in his own house. At the same time it symbolises time, beyond reality and contingency. The symbols appear in pairs and are given new forms of life: clock-fish, then hen-fish where the fish is the depth of the sea and the bottom of the subconscious at one and the same time, though Chagall wants to transport it into the luminous spaces of the sky. This tendency to symbolise was already a part of Russian tradition as, in fact, of all Early Christian painting. But Chagall brings these symbols back to life. He rediscovers them from inside as if they had emerged intact from the dawn of the world. Just as the fish is the symbol of water and the moon, so is the hen symbolic of fire and sunshine, in other words, of life itself. Thus fish, clocks, asses and hens float up and down in extended landscapes or are themselves the landscape: a landscape that the painter continues to view without plunging into it himself, but from its edge without entirely forgetting himself. 'Chagall never comes down into his landscape: he looks at it from afar, as though it had been summoned up from a dream, a loving

Fig. 21

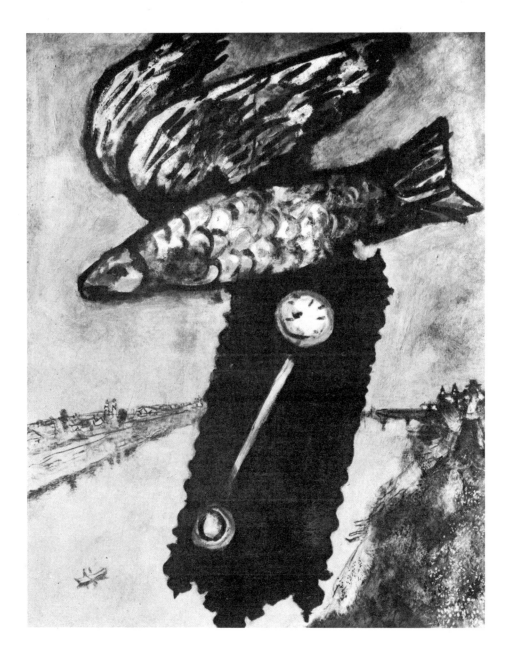

21 *Time has no Banks*
first version, 1930, oil on canvas
$40\frac{9}{16} \times 32\frac{11}{16}$ in (103 × 83 cm)

daydream,' said Lionello Venturi; and the matter could hardly be more accurately described.

They were busy years of illustration too. After *Dead Souls* and the *Fables* of La Fontaine, which he finished in 1930, he began the illustrations to another book, one more dear to him than any other: the Bible. The commissions for all these came from Vollard, who besides being an editor of unfailing taste, was also an understanding friend. The text of the *Fables*, re-interpreted from Aesop, where the wise animals have always stood as symbols, was a subject perfectly suited to Chagall, while the Bible was a subject utterly in harmony with his inner world. 'I did not see the *Bible*: I dreamed it.' He had known it well from infancy. It is the great myth that every Jew carries about with him as his bundle, the consolation of his secular wanderings. 'For Jewish people alone these stories are the history of their forefathers and the living reality which is of prime importance in the history of each individual too whether he wishes it or not.' But he felt that he needed real contact with the Hebrew world to illustrate the Bible, with his ancestors' soil, at least as inspiration. Thus he set off for Palestine for the first time in 1931.

In this case we are dealing with a new kind of pilgrimage. He went not only to steep himself in history and to see the places but to discover the different light of those places, to snatch the secret of their simplicity from those bare hills where Christ's last drama took place, near the lakes and rivers where the prophets had lived. It was a return to his homeland in a sense

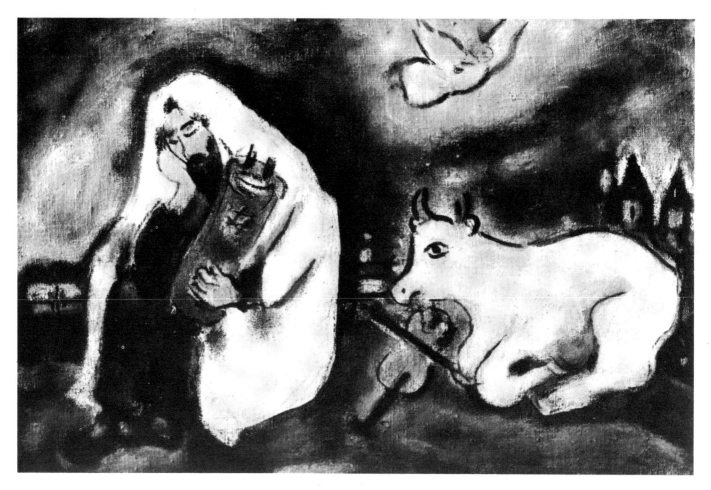

even more real than the journey to Russia. The *Bible* was begun in 1931 and continued until war broke out in 1939. He broke off at the death of Vollard in 1940 and resumed it in 1947, bringing it to a conclusion in 1956. It was published a year later by Tériade, who was moral heir to Vollard. It is the story of the Jewish people, from their experience in Palestine up until their latest persecutions. It begins with the Creation, calm and Olympic, and passes from the story of Abraham to the prophets and patriarchs, with a continuous parallelism between the stories of the Old Testament and contemporary history. It is particularly interesting to note how all the illustrations, throughout this great working span, also tell the story of Chagall himself and have all a singularly first-hand character, although they are certainly not lacking in iconographic allusions to widely differing sources such as ancient icons, Rembrandt and Goya.

Fig. 22

One painting, contemporary with the first phase of illustrations for the Bible, *Solitude* of 1933, seems to mirror the artist's mental state at the time of the Palestine venture. It is the image of the wandering Jew, in exile, who, cut off from the world, is praying. Once more we see a symbol of the world of nature, the cow; there is also a violin and a piece of ground which he has to leave–nothing else. 'The world's grief is present too, under the guise of grave, melancholy contemplation. But the symbols of comfort are never far away. A poor creature may sit in the snow, but he can play his violin all the same. A rabbi holding the *Torah* (the collection of holy scriptures) may be sunk in a sorrowing dream, but the innocent cow at his side may express the vast quiet of the universe,' as Raissa Maritain says of the picture.

After 1930, nudes reappear, but quite different from the nudes of the early Russian period. Lovers reappear too, and another autobiographical picture of Bella and himself projected into the couples from all over the world. There are landscapes recalling Russia and above all, flowers: flowers in the foreground right up against the edge of the picture, standing out against realities of the past that hover in the background. *The Bride's Chair,* with its triumphant flowers, dates from this period. It was copied from the real one made on the occasion of his marriage, and in it the colour of the flowers

seems to dissolve in a luminous whiteness symbolic of purity and serenity.

About 1932 new features begin to appear. There is almost a whiff of dramatic presentiment of the Spanish War and the anti-Semetic struggles in Germany which were to have so profound an effect on Chagall both as man and artist. The optimism, certainty and pre-eminence of the dream, such as we found in the years 1920-30, now give way to darker harmonies. The colour assumes more body and weight. No longer does it manage or even want to be fluid and vaporous: it seems to wish to deny itself the happiness and weightlessness which is chiefly expressed in colour. This change persisted throughout the next decade, relating to a crisis that was taking place inside his painting too.

He returned to realism, to a harsh, strong realism, particularly in the portraits, such as *Bella in Green* of 1934. Here Bella's look is lost, far away in the remote and uncertain distance; we see the portrait of a person who is suffering and whose suffering remains isolated, unmixed with the wider yearnings of humanity. Chagall was trying to discover his second style through subjects that only later bore real fruit in masterpieces such as *At Dusk* of 1943. Once again he became engrossed with ancient art and travelled abroad. He visited Spain, and studied Velasquez, Goya and especially El Greco. He intensified his attachment to Rembrandt through the engravings of biblical subjects which he saw on a journey to Holland. In 1935 he even went to Poland to make a closer study of the dramatic life of Jews in that country. From this trip he received impressions that were to give rise to a new series, that of the *Revolution* which was to start in 1937. It was during this trip also that he painted the *Interior of the Synagogue in Wilna*.

Fig. 23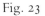

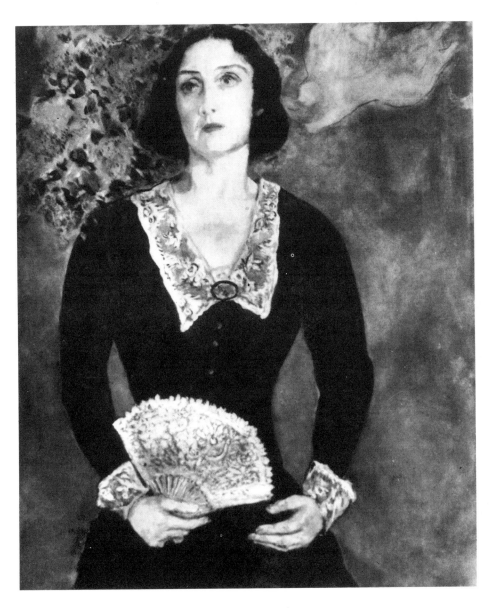

23 Bella in Green
1934–35, oil on canvas
$39\frac{3}{8} \times 31\frac{1}{2}$ in (100 × 81 cm)
Stedelijk Museum,
Amsterdam

The large compositions

In the decade 1930-40 he produced some of his largest, most famous compositions, such as *To my Wife* and *Acrobats* (which he later divided into two), *Wedding Lights* and *All Around Her,* all of which are returns to subjects that had germinated between 1910 and 1914. In addition to these, there are new features from the Jewish theatre, of which he was always extremely fond, just as he had been in Paris with his early stage decors and with the panels painted for the walls of the very hall in which the theatre took place. In these years the usual symbolic elements are no longer isolated but orchestrated. The same applies to the colours, which are no longer separate notes but a symphony, which has been described as 'an undulating shimmer of colour'. A particularly important painting, as we can tell from the long time it took to reach completion (from 1923 to 1933 and then to 1947), is *The Fall of the Angel,* which is permeated with the apocalyptic and the demoniacal. The angel, looking like a strange, inflamed butterfly breaking the calm of life, present and past at once, is catapulted into the sky at the same moment as the clock. The forces of nature, meanwhile, the candlelight and the animal playing a fiddle, reveal themselves to the angel's fall in all their essential symbolism.

The painting called *The Revolution* was fundamental to the development of his political ideas, though it was itself cut into three when events changed the sense of this very revolution as the artist had understood it. The picture was born with the Spanish revolution and dictated by it. The large composition is divided into two areas; on the left is the true revolution – the mass of people, the dead man and the grave all describe the effects of revolution. On the right is the artistic humane revolution which Chagall himself proposed and announced as good tidings. In the middle of the group of main characters is Lenin, who is the turning point, in the guise of an acrobat, like the needle on some scales around which revolve the two balanced halves, the political and the human-artistic. This must have been Chagall's own political manifesto expressing both his political and his artistic ideals. His message is based on music and love opposed to the screams, arms, deaths and graves of the revolution; and it is amusing to remark how his message antedates by thirty years at least the slogan of the youth of today, 'Make love not war'.

The final years of the decade are characterised by a wider expansion; and

Fig. 25

Fig. 24

24 The Revolution
1937, oil on canvas (later divided into three parts)

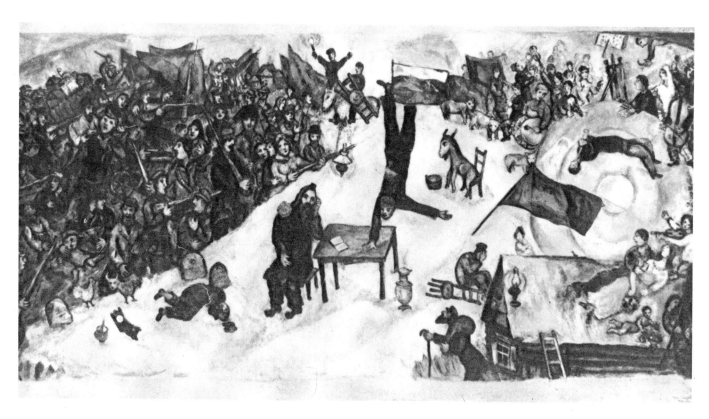

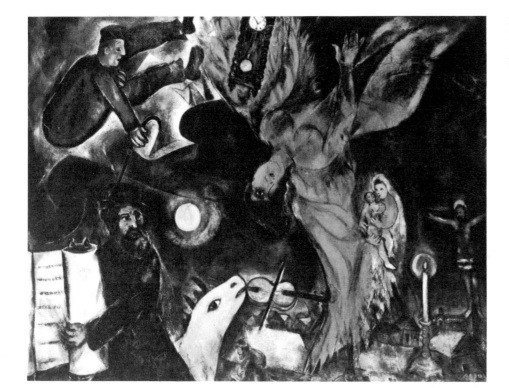

25 *The Fall of the Angel*
1923–33–47, oil on canvas
58¼ × 26 in (148 × 166 cm)
bequest to Basel Museum

an element of serenity both in nature and humanity takes root. A journey to Italy, and especially Florence, reawakened his contact with tradition and the great painting of the past. The works of Giambellino, Tintoretto and the dense, weighty Titians made most impact. Even in his choice of subjects we can discern a greater tranquility, a calmer contemplation of life, and there is greater harmony between his personal sensuality and the release of pressure in the world around him.

As he achieved glory he also became financially secure, and he acquired a sumptuous, huge new studio. He was at last granted French citizenship; Chagall the Russian, Chagall the wandering Jew, deceived by political events and by contingent realities too harsh for him, at last found comfort and protection in his new homeland. His tensions yielded before an ordinary calm whose fundamental quality is to be noted in his family feelings, in the birth of his daughter and in what amounted to acceptance into society. But even in the moment of public recognition of his art, the world of his childhood retained a chosen corner of his heart and became indelibly fixed there, purified and dimmed by distance. This was the time when his favourite themes suddenly plunged into blue light: his circus figures became conjoined like young shoots of the same plant, germinated by nature. And when we gaze into the paintings we might call 'bewitched', the note of fable, the intruding animals, the plants and the human figures, all breathe a simpler, calmer, more level atmosphere.

His technique followed his mind and inspiration: it became richer, more sensual, and almost blossomed. In the old subjects he resumed in gouache the shades are denser, duskier, more charged, and seem permeated with intense light. He painted the vivid, galloping *Red Horse* and *The Cellist,* a final version of this often repeated theme of which Erben writes: 'The player, a two-faced Orpheus, is himself the instrument played by his hands. And the houses of Vitebsk, this time packed closely together, are the walls of Thebes which his song causes to rise up.' Everything is joined together in this work: man and instrument, faces in profile and full-view, hair and sky. Orpheus's concerto is not his own alone, it is the animal's too: it is the concerto of all forms impregnated with colour, entire strata of colour which unite and sing together. Colour which has thus become a ductile instrument of many forms reaches its peak in *Time has No Banks* of 1939, the *Loving Couple by the Eiffel Tower* and *A Summer Night's Dream.* Fig. 26

War and America

The artist enjoyed another spell of serenity, a period of waiting prior to another crisis, in Gordes, a quiet beach in Provence, not far from Marseilles, enlivened only by fishermen's boats and the sound of the sea. There he shut himself away with Bella. The reasons for his withdrawal were firstly, to avoid the trouble that was being made for Jews and secondly, to enjoy and paint the Mediterranean beaches—for the last time before his enforced departure to America, where the new war was to drive him. From Gordes he said farewell to France while the Americans who were resolved to assist him made the first of their arrangements to ensure that such an important figure should not be bothered or oppressed by the war. He meditated once again on a fate that constantly drove him to emigrate: 'A wall has grown up between me and my people, a mountain covered with grass and graves.'

On May 7 1941 he set out for Lisbon whence he sailed to America with all his pictures—all the work that he had accomplished in years and years of application. This was another exodus in every sense of the word, with fear and questioning of an unknown land, which if not actually inimical would certainly be different. The final paintings before his departure from Gordes are violent, sensual yet dreaming palpitations, such as the *Red Cock*. Or they are sorrowful, as though predicting a drama about to be wrought, such as the *Self Portrait in front of the Easel,* a clear symbol of sacrifice, war and flight: the end of an era.

Fig. 27

26 *Summer Night's Dream*
1939, oil on canvas
$46\frac{1}{16} \times 34\frac{7}{8}$ in (117×88.5 cm)
Musée de Peinture et Sculpture,
Grenoble

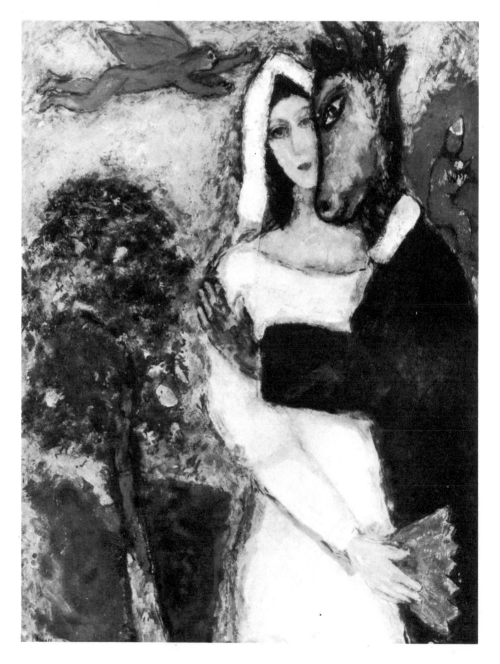

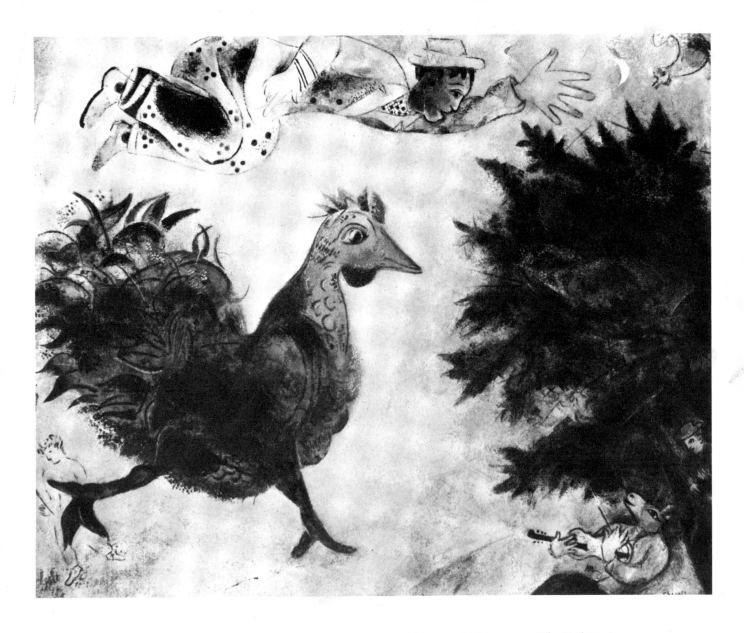

But the new sights that greeted him were not negative as the wandering Jew had feared: there were trees and animals in America too. Indeed, in New York, where he was welcomed with triumph, and in Mexico, where he enjoyed his first exploratory trip, Chagall was overwhelmed by a series of new emotions and stimulated by new sparkling colours; he had not time for melancholy. He was immediately commissioned to design the scenery and costumes for *Aleko,* and for *The Gypsies* by Pushkin with choreography by Massine and music by Tchaikowski. At last he took up his beloved theatre work again. In *Aleko* he seems to relive all the emotions of Mexico, its colours, its papier-maché masks, its costumes and festivals. He expresses its natural life, bursting with sap alongside scorched, arid desert, a country full of contrasts, of violence and vitality, where flowers bloom out of rock with miraculous colours while a parched mule struggles uphill along the dry track to find relief in the little shadow of a cactus. This was all displayed in the splendid triumphal exhibition that was mounted in New York in 1942. In these days America also carried him back to Russia with the resurgence of features from his homeland now renewed disjointedly through the war. The houses in these pictures are on fire, the countryside devastated before the eyes of grieving crucifixes, streets are red with fires and black clouds billow through the skies. Russian actors and poets came to keep him company, and together they talked of their common homeland, invaded and threatened.

Now the fantastic images, the women, the asses and the cocks, which are the outward expression of something fixed in his imagination, represent his fears and anxieties. Such is *The Juggler,* who is the artist himself, and

27 *The Red Cock*
1940, oil on canvas
$30\frac{3}{8} \times 35\frac{13}{16}$ in (72 × 91 cm)
Johnson collection,
Glendale, Ohio

Fig. 29

28 *At Dusk*
1943, oil on canvas
$39\frac{3}{8} \times 28\frac{3}{4}$ in (100×73 cm)
private collection,
Berne

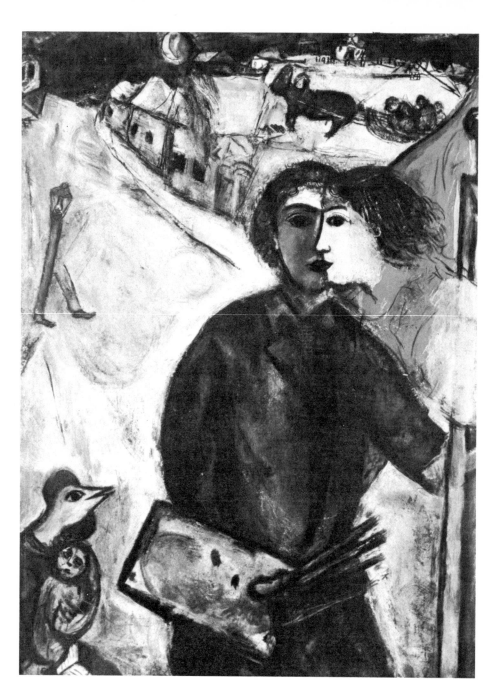

Fig. 28 *At Dusk,* and both reveal the living sensations of these other lives. *At Dusk* is especially important, a real landmark in his work: the lantern struts across the left while the faces of the two lovers are seen to be the French flag. The traveller is, of course, himself, just as he is the painter of the lovers, and the snow that forms a backcloth is Russia, omnipresent, even more so during this exile far off in America. He resumed his circus characters in *The Harlequins* of 1943, which reveal points of contact with Bruegel in their style and rhythm. A greater fusion of material in moving from one area to another and a definite maturity of palette are marked in such paintings as the *Red Horse, Dedication to my Wife* and the stupendous *Moonlight,* which revels in the freest possible gouache technique to achieve special effects in lyrical shading.

Pl. 25

Exit Bella

Then, suddenly, a harsh blow. A new and entirely personal tragedy came to overthrow his balance and impede his inspiration for many months to come. This tragedy, the heaviest in his life, was the death of his ideal companion – not merely wife but counsellor, critic and first assistant in his poetic world. On September 2 1945 Bella died. And with the death of his muse, every means of expression, every possibility of revival seemed to die inside Chagall the poet. His pictures stayed in mourning with their faces turned to the walls as though their colours must have died and could no

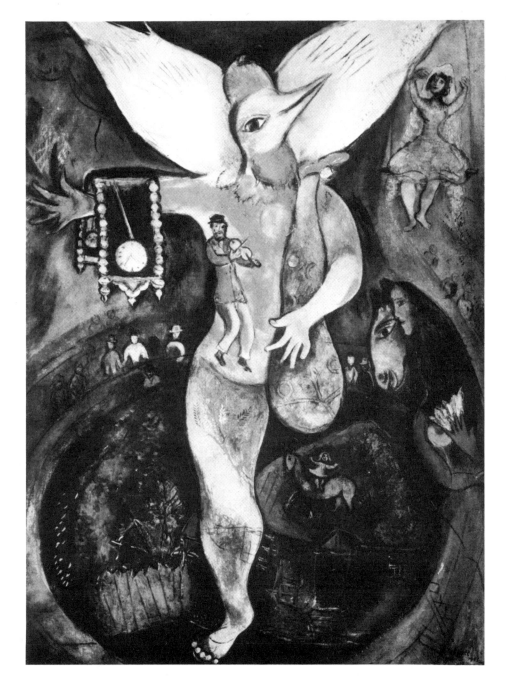

29 *The Juggler*
1943, oil on canvas
$43\frac{1}{4} \times 30$ in (110.5×78.7 cm)
G. Chapman-Goodspead collection,
New York

longer express words and music. They were silent for nine months, until
the spring of 1946. During all this time the artist thought only of printing
Bella's memoirs *Lighted Lamps*.

Later, however, although the silence seemed to be stretching out forever,
life began again. The broken chain was repaired with *The Soul of the City*, Pl. 28
in which Bella appears as if eternally caught in flight dressed as a bride, her
white face alongside a mask of herself; the eternal myth of his painting and
returned once again. To help him start again he was asked to do the scenes
and costumes for Stravinsky's *Firebird*, organised by the New York Theatre
Ballet, and as always, the theatrical projects fascinated him and took com-
plete possession of him even physically. A new kind of abstraction domi-
nates the sketches and the actual scenery for the ballet: trees, animals and
faces no longer exist for themselves but become an integral part of the
pictorial space. It is the colour itself which becomes the shape of a cock,
a tree or a clown, as when a fleecy, shapeless cloud in the sky gradually
assumes a definite shape as if by accident, though in fact by a puff of the
wind.

He remained in America from 1946 to 1948, and several important events
followed. A vast retrospective exhibition was mounted in New York in
1946, which collected all the work done since his previous exhibition,
held in Basel in 1933. The other important commission was the one Eluard

30 *Self Portrait*
with Clock on the Wall
1947, oil on canvas
$33\frac{7}{8} \times 27\frac{1}{4}$ in (86 × 70.5 cm)
property of the artist

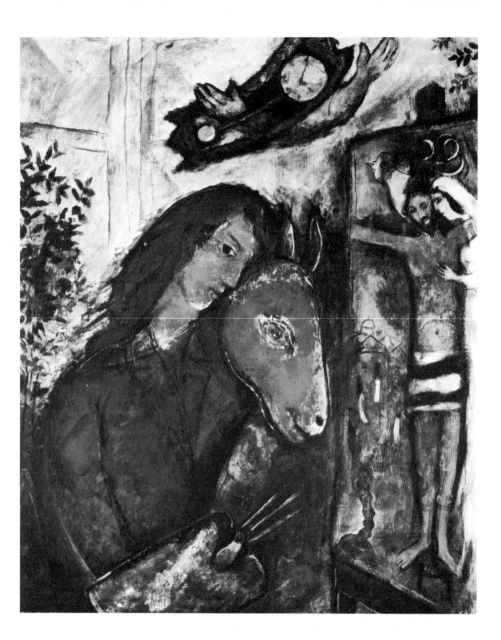

himself had given him in Paris, namely the illustrations for his poetry. A more exhausting job was the series of lithographs illustrating *The Thousand and One Nights,* his last work before returning to Europe. Also from this period is the *Self Portrait with Clock on the Wall,* where the painter's head is repeated in the head of the ass, and the green crucifix, already painted on the artist's easel, is being consoled by a white ghost, the ghost of Bella. We shall also remember the violence and power of the *Flayed Ox,* immolated like Christ, the symbol of a futile, terrible sacrifice. There is also *The Fall of the Angel,* which presents the re-elaboration of a subject which had already appeared in 1933, with the difference that now recent dramatic experiences have emphasised the parallel between recent historical catastrophes and the angel's fall, the cosmic catastrophe. The negative destructive principle of the fire fallen from heaven is, of course, evil, war and the whole mystery that enwraps humanity.

The chemistry of painting

On his eventual return to France in 1949 Chagall made contact with Tériade, Vollard's heir, from Orgeval. He also resumed etching, to finish his illustrations for the Bible. *Dead Souls* had been published at last in 1948; La Fontaine's *Fables* were to come before the public in 1952. The Bible illustrations, however, were not finished till 1956. In Paris he renewed his connection with the theatre in a new show which he threw himself into with great enthusiasm: the decor for Stravinsky's *Daphnis and Chloe,* whose mythical subject he studied at great length and became extremely fond of. Chagall's close tie with music has often been underlined in addition to that

Fig. 30

Pl. 30

Fig. 25

with the theatre. It could not be otherwise, yet it does not seem right to pair his name, as some have done, with that of Mozart. Logically one would expect that Russian composers and the Impressionists above all would be closest to him, with their taste for colour and imagination. Thus the Stravinsky of *The Firebird* or *Petrushka* and the lyrical washes of Debussy are certainly closer to his style and his particular sensibility. Gradually the artist abandoned Paris and came closer and closer to the shores of the Mediterranean. First to St Jean, near Nice, then for many years to Vence and finally to St Paul, near Vence. The atmosphere of the South, with its flowers, colours and light, engendered a new, free manner in paintings such as *Fish in St Jean* or *The Red Sun*. These paintings date from 1950-51; they are utterly beautiful, blended, refined and constructed in a material that looks like enamel, in spacious rhythms. All around the certainty of these wide spaces there vibrates an atmosphere of calm. The forms in movement, the couple climbing a trellis in *The Red Sun,* or that which rises up like a two-headed dawn from the spreading blueness diffused by *The Fish,* and the fish themselves in precious red, like jewels set in the vivid deep sapphire of the sea, are all the fruits of this happy time. Like a symbol the bunch of flowers washed in yellow floats in the sky, a strange air-body of purest imagination.

Fig. 31

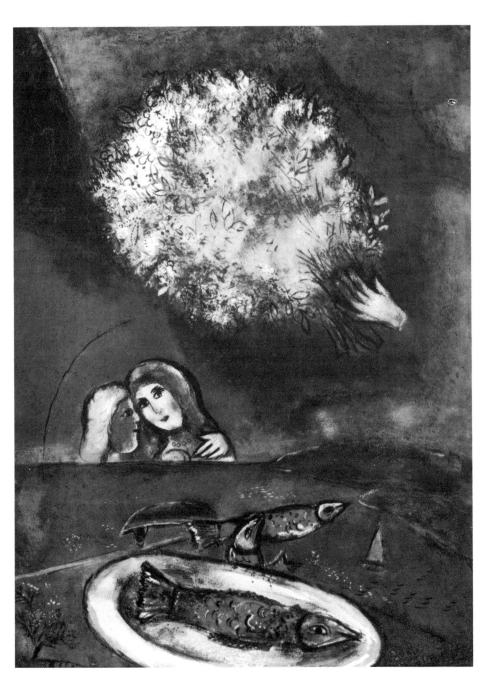

31 *Fish at St Jean*
1949, gouache on paper
$31\frac{1}{8} \times 22\frac{13}{16}$ in (79 × 58 cm)
Nacht collection,
Paris

Once settled at Vence, he often painted the countryside as he could see it from the window of his studio: in the foregrounds there are still olives, vegetables, fruit and flowers that have the primitive tang of the land of Provence. It is as though the breath of the surrounding land has come in at the window to become part of the picture. And the cock inevitably appears: this inextinguishable cock-a-doodle-doo of life together with the lovers, who day by day in their millions make up this life. Line representation of the sun always appears, too – the sun, always the sun but always different. Sometimes it is a suspended, weighty disc, sometimes a brilliant note in the dense thickness of the heavens, sometimes a diaphanous dissolution into light of shapes made substantial by colour. In substance and dimensions he tended towards monumental compositions like *The Wedding* or *King David*.

It was during this period that he formed a plan to decorate a chapel near Vence with biblical figures. The plan came to nothing, but many of the paintings from this biblical series remain. This was to be the crowning achievement of a long cherished dream: to collect in one holy place the entire output of his constant feeling derived from the relation of man with God. This constant mystical note is always heard vividly in his aesthetic and was not exhausted in the illustrations for the Bible. He also branched out into a new field which seems naturally connected with the actual place in which he had made his home. This was pottery.

First of all he painted ready-made pieces. Then he himself modelled the figures in the clay from his own imaginative world. He made attempts at sculpture, attacking huge blocks of stone, blocks which stayed blocks even if cut into shapes, like Roman capitals. The churches of Provence, of course, and the local flowering of an ancient plastic tradition, were not unconnected

32 *The Banks of the Seine*
1953, oil on canvas
$37\frac{1}{8} \times 26\frac{3}{4}$ in (79 × 68 cm)
Vava Chagall collection,
Vence

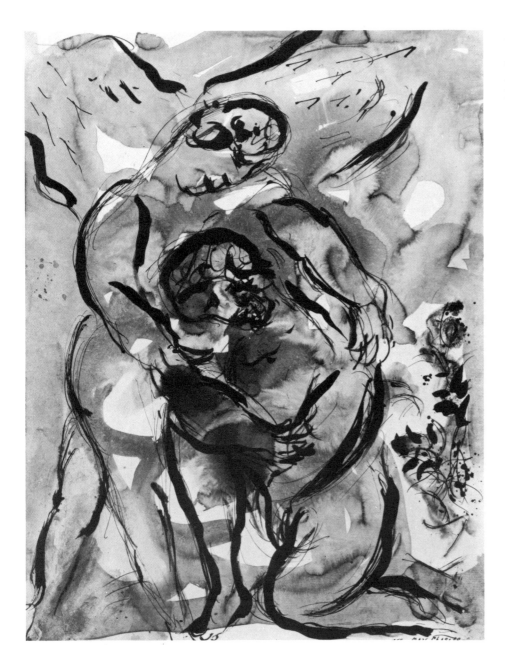

33 *Jacob wrestling with the Angel*
1955, black ink and gouache
on paper
$25\frac{9}{16} \times 19\frac{11}{16}$ in (65×50 cm)
property of the artist

with his own positive experiments. But he now began to work in every field, with no limits. There is a superb series of lithographs on the theme of *les mauvais sujets* which he carried out in Paris during his frequent short absences from Vence in 1960. Lithography is probably even more suited than etching to Chagall's sensual character with its tense eagerness to expand and express itself with immediacy. And he made great use of the Mourlot studio, that is to say of all the best that there is in the world. His lithographs were published in *Verve* and *Derrière le Miroir,* elegant reviews edited by Maeght, who inherited from then on the exclusive right to Chagall's works, giving exhibitions of the latest achievements in the galleries of Vence and in Paris. 'On touching the lithographic stone,' says Chagall, 'I felt, as I did with the copper plate, as if I were touching a talisman which had been with me from my earliest years: by means of these instruments I seemed to be able to pour out all my miseries and joys.'

And at last in 1952 he met Valentine, his Vava, who became the second trusty companion of his lifetime. 1952 also saw the start of a Parisian series – he had rediscovered Paris after America. 'Paris is a picture, a picture already painted. In America I first felt the need to paint it.' In fact he had realised how much he loved Paris just after his final stay in America; he loved it as much as Vitebsk and even in place of Vitebsk. The place of his birth was utterly altered after the war, demolished and rebuilt. There are no longer wooden shacks, nor palisades and crooked alleys covered in snow, the

theatre of his one-time little figures. Vitebsk, as it is now, is no longer his. Only in his imagination will it remain the ideal that it was. Paris, however, will not change, cannot change any more: it is constant. He rediscovered it with his *Banks of the Seine* in 1953, a yellow streak filled with humour and life skims over a maternal scene which glows with red light, while a green animal sails by in mid-air.

Fig. 32

During this period Chagall repeatedly used the word 'chemistry' when talking about painting, both his own and others! By chemistry he means the actual alchemy of the colour material used as a means of resolving and clarifying the 'idea in the mind'; as a way of explaining all the rational

34 Window for Metz Cathedral
1959–60, stained glass

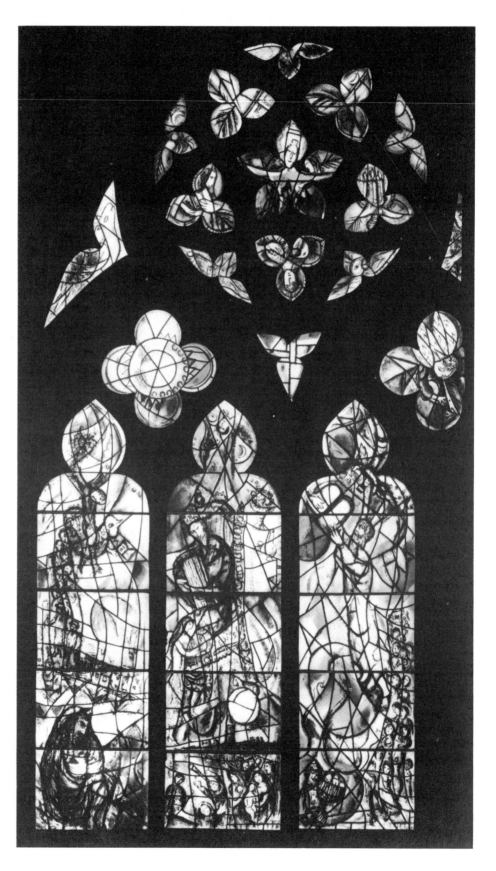

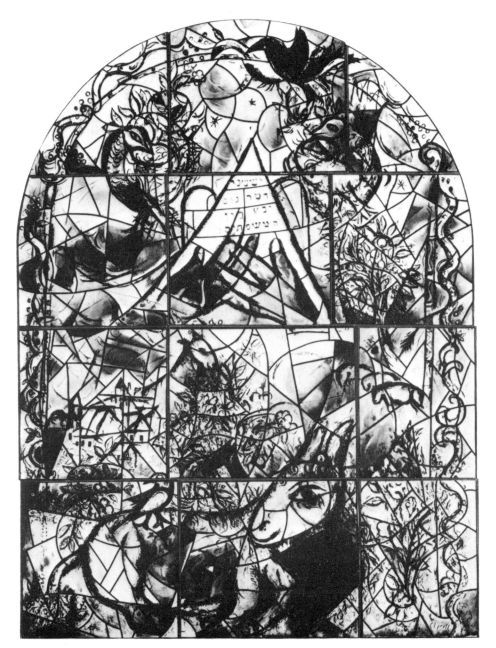

35 *The Tribe of Issaker*
1961, window for the Synagogue
of the Hospital
of Hadassah near Jerusalem

chains of the symbol. What is expressed in the richness of colour, form and
motif, by a process of osmosis is the idea in the mind. Thus everything that
is irradiated by thought comes alive, chemically vital as in a ferment. Even
when talking about other painters he comments: 'I do not embark on even
the first stage of an exposition if my eyes encounter a chemical impossi-
bility'; as though the artist really had the power, like the old alchemists,
to filter through the still of his imagination, by means of a particular tech-
nique, the reaction of the elements of reality which is then distilled in sym-
bols. In Chagall's view only the true artist possesses chemistry: the false
artist has none, as though it were a matter of some synthetic substance which
is not naturally produced but coldly concocted in a laboratory. The artist-
chemist really is a magician, whose chemistry is the fruit of a miracle.
Chagall speaks warmly of the chemistry of Cimabue, Masaccio, Titian,
Cézanne and especially Monet. 'He could even give up drawing, so power-
ful was his colour. His eye beheld not the single element but the complete
union of light and substance, the chemistry of nature.'

Following the *Daphnis and Chloe* cycle, he was enriched by the journey
he made to Greece with Vava; he had gone to find a point of contact with
the classical world, to give him ideas for the ballet he was preparing. There
he lost himself in the countryside, in the tranquillity of mystical Greece, and
on his return to Vence he found bits of Greece in every part of the Medi-
terranean; we recognise it in *The White Window*. There followed the Pl. 34

abortive plan we have already referred to, namely to paint the Calvary chapel, near Vence, with biblical scenes. Then, after decorating the Baptistery of Notre Dame de Toute Grâce on the plateau of Assy, which he did for Father Couturier and which was his first work in a Catholic church, there arose the occasion for another new venture. This was the stained glass of the Cathedral of Metz, which he accomplished in 1959. This was followed by more stained glass in the synagogue of Hadassah at Ein Karem near Jerusalem. In the first windows he encountered the considerable difficulty of having to insert them into a Gothic structure alongside 16th-century windows. His solution, however, was absolutely successful. But with the second windows he had complete freedom, as they were to go into a contemporary building. Here once more the element that was always basic to his work, light, was again absolutely fundamental. Chagall worked with the light; he used a new technique to scratch the colour (which he had already spread and baked) in such a way that he achieved truly personal effects and authentic adjustments of light so as to model the material as much as possible as he had always done with his paint brushes. The result was a triumph: some of the most successful windows of recent years.

Fig. 34

He was no longer satisfied by the techniques in which he was already expert, such as oils, gouaches, etching, lithography, ceramics and sculpture in stone. Now it was glass, later it was to be tapestry. He was to produce the great wall hangings for the Parliament in Israel in which he so successfully transferred the style of the carbons that he recaptured in thread the same impressionistic immediacy of the brush strokes, liquid and flaming. Eventually he also took up mosaic work, on which he is still engaged. One of his designs was executed in mosaic not many years ago by the Mosaic School in Ravenna. Finally, to get back to painting, he achieved two colossal tasks, two vast panels for the new theatre in New York and the ceiling of the Paris Opera, where Malraux had wished to cover the heavy monstrous 19th-century ceiling with an airy fantasy by Chagall depicting the theatre of all times.

It is wonderful to see now, with what lightness and with what richness of characters, colours, imagination and ideas he has managed to fill up the enormous area of that ceiling, making a wheel out of it, an imaginary revolve which gives no hint of the scale of labour involved even physically. Nor does it reveal the passing of the years, only the freshness of his imagination and its eternal fecundity. For Chagall that imagination and that technique are one thing, painting. 'Painting was as necessary to me as bread. It seemed like a window I could escape out of, to get away to another world.' These are words Chagall spoke at a conference in 1958 and they are still valid.

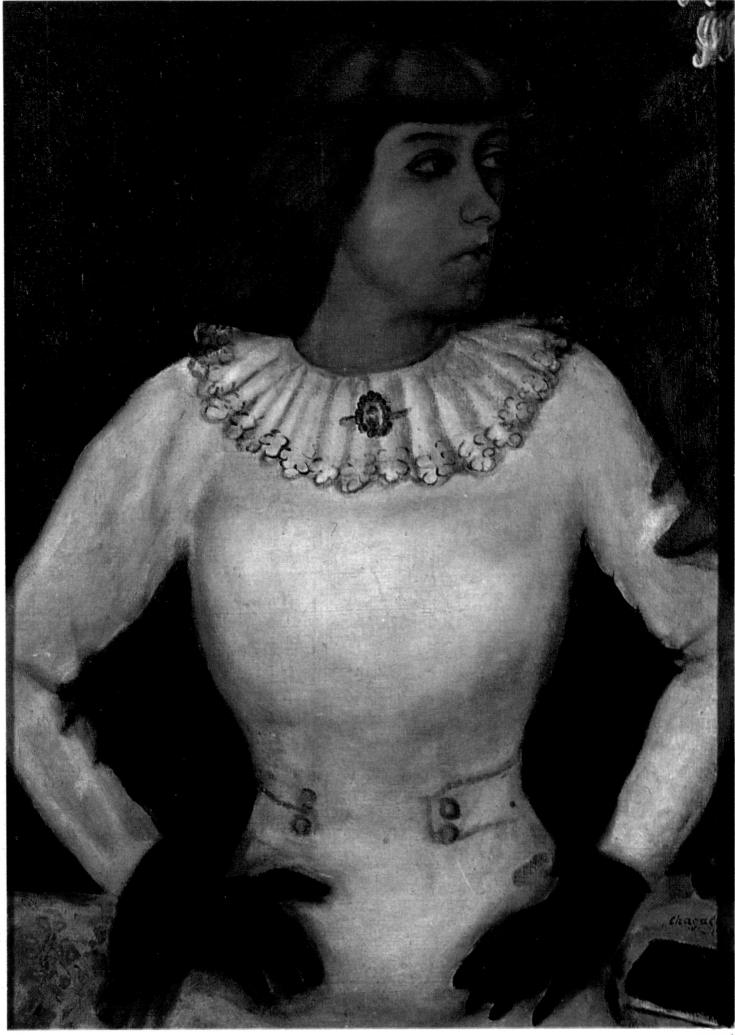

1

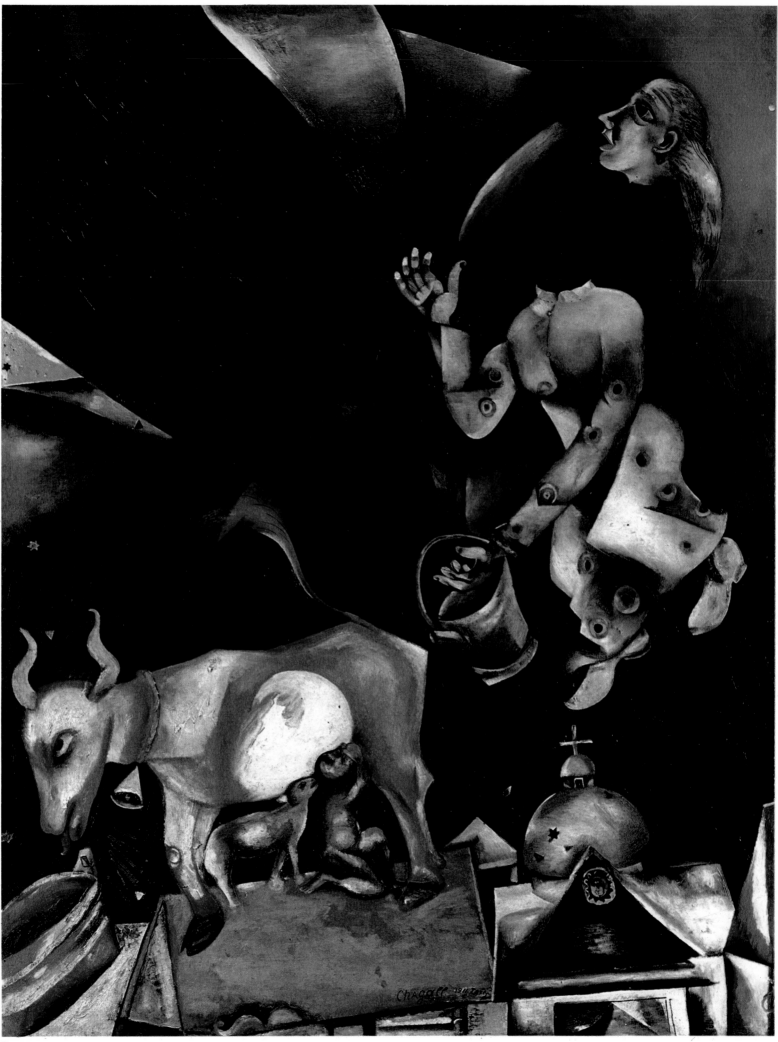

2

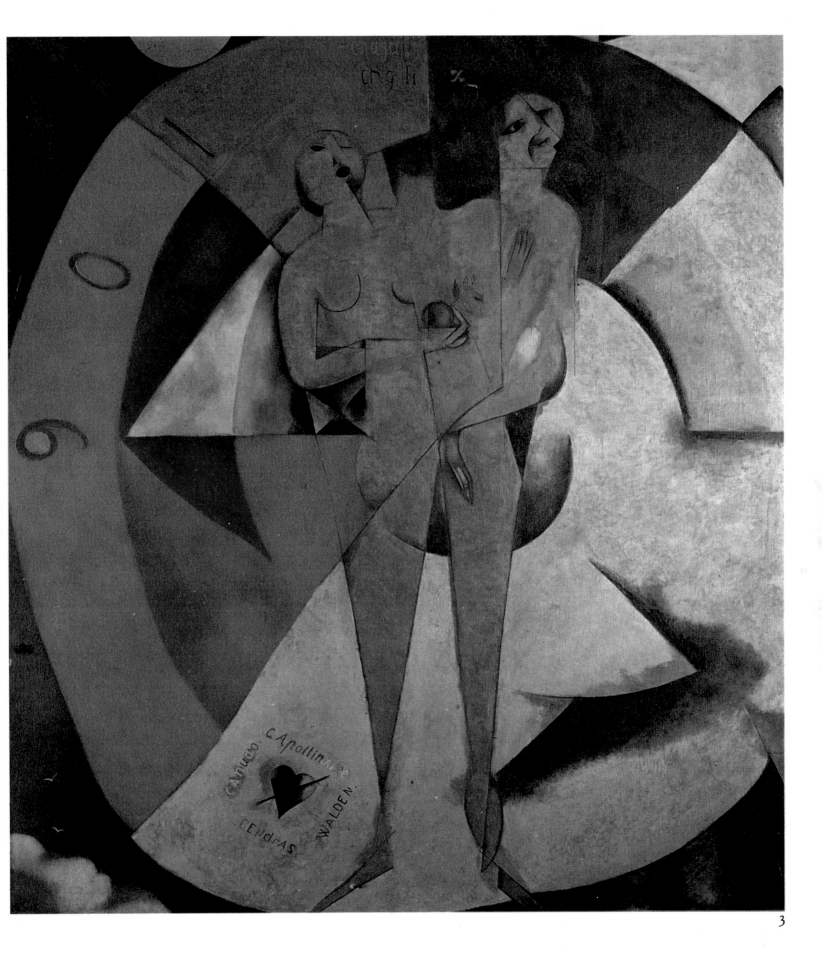

4-5

6

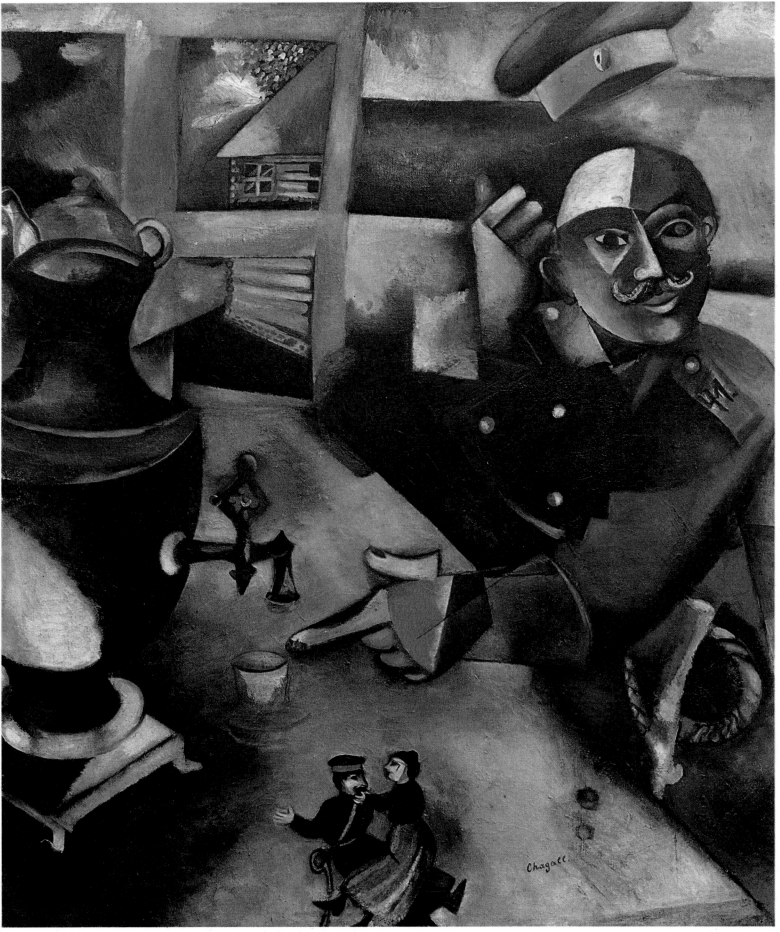

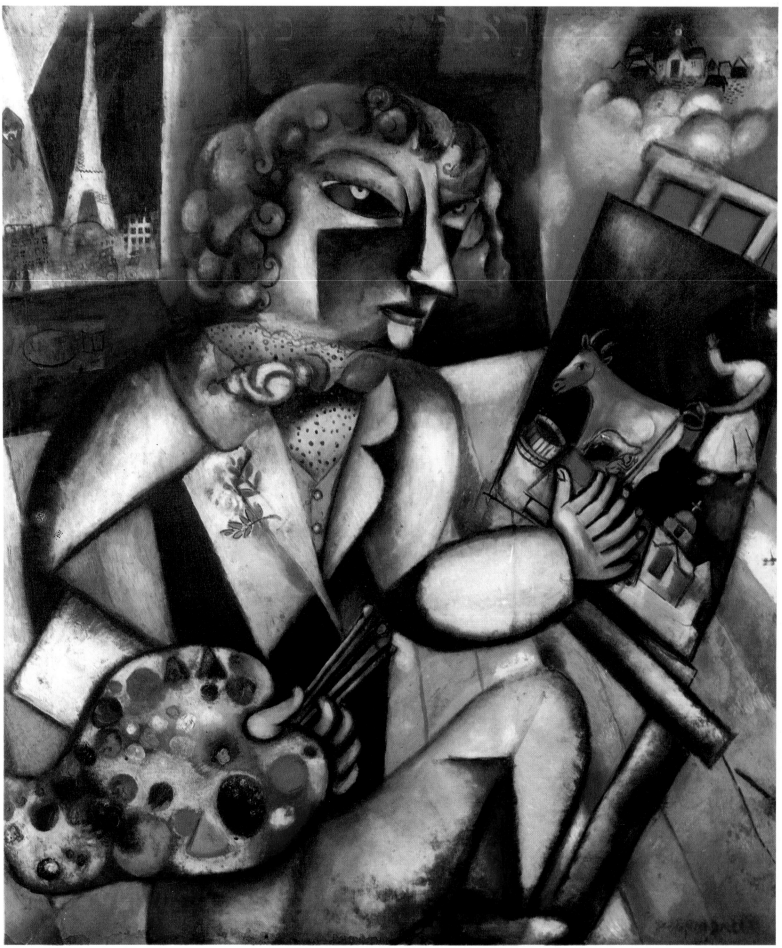

8

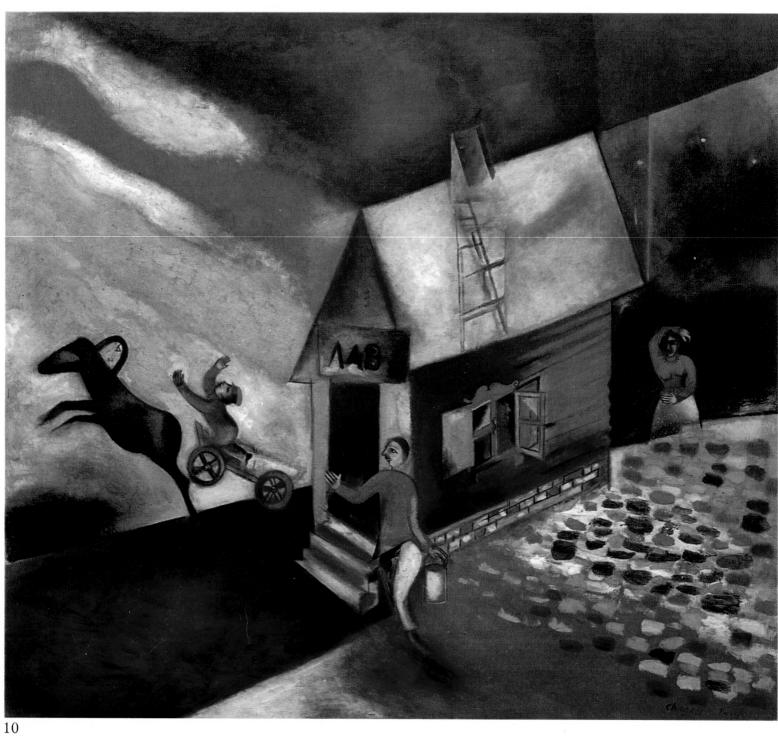

10

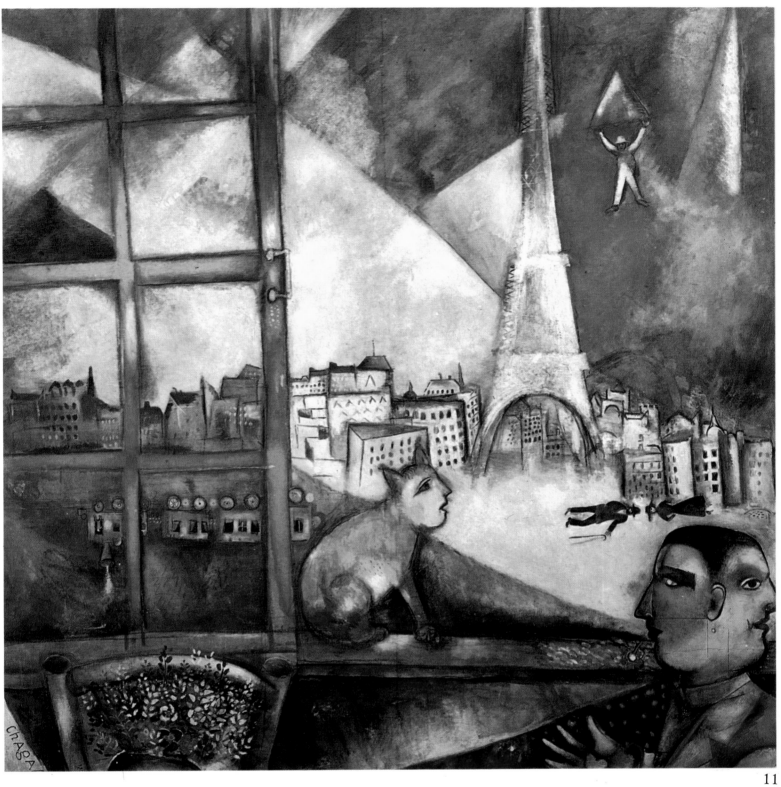

14

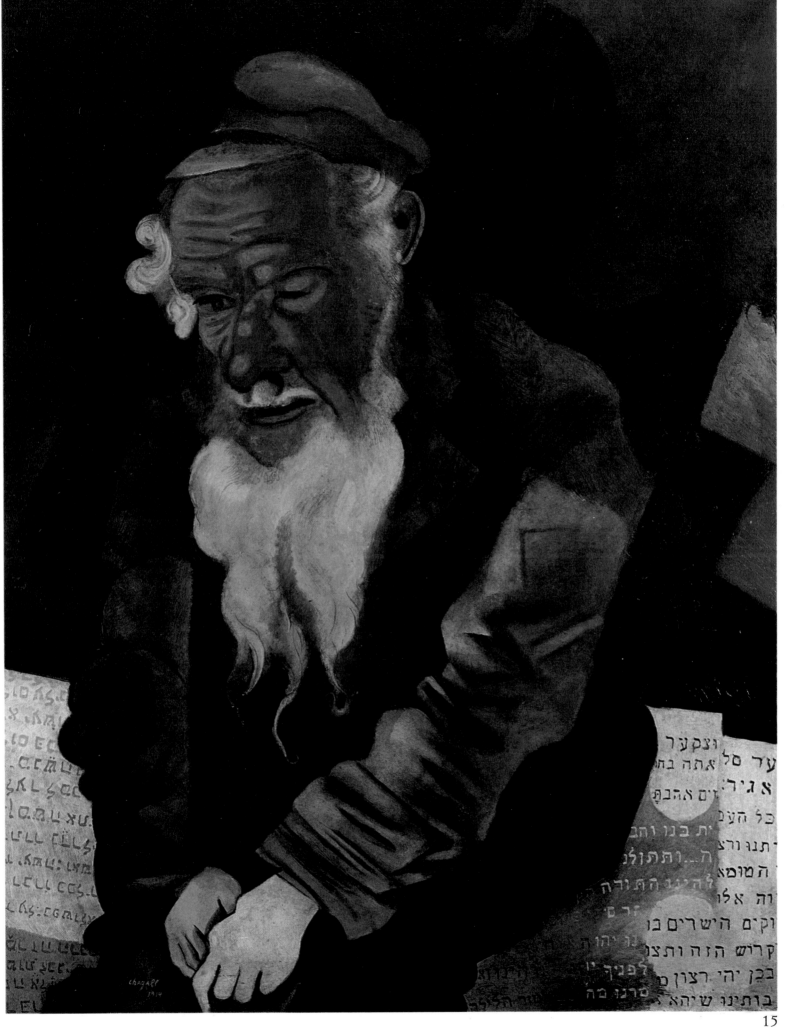

16

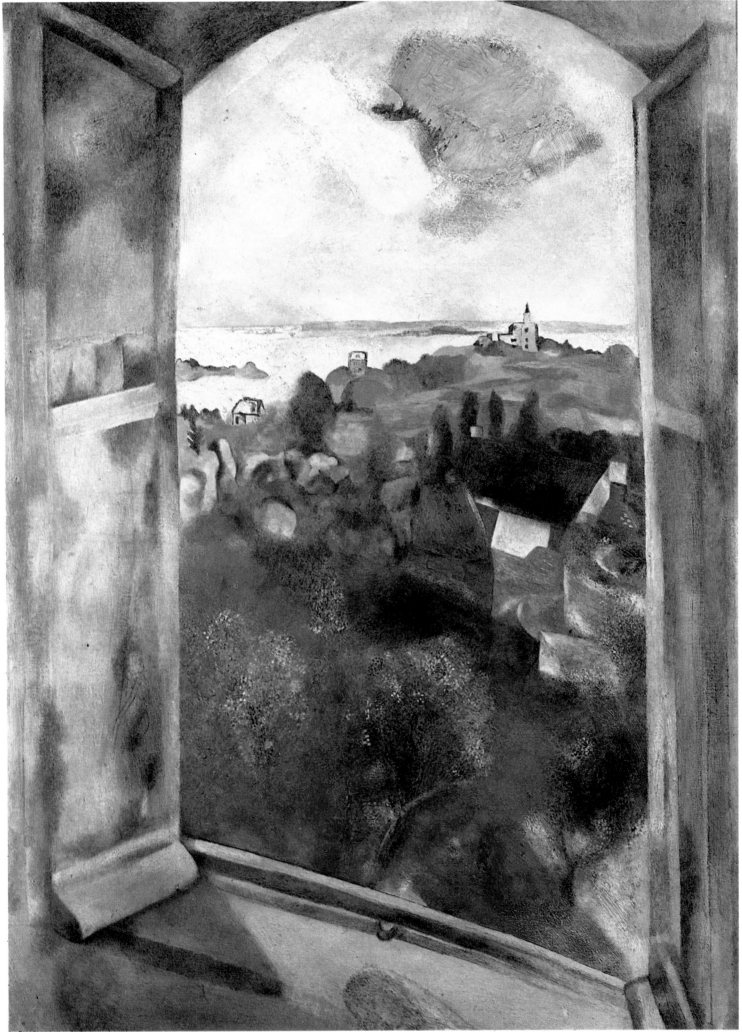

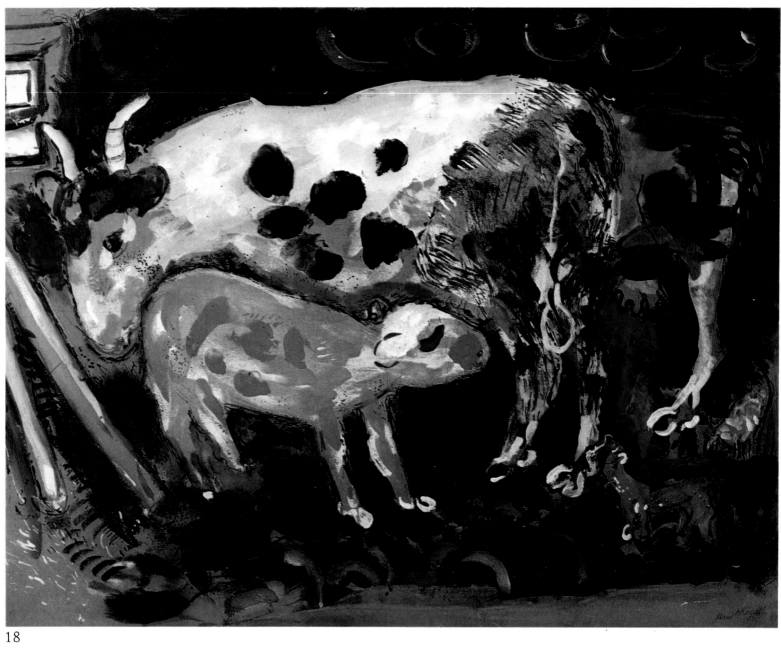

18

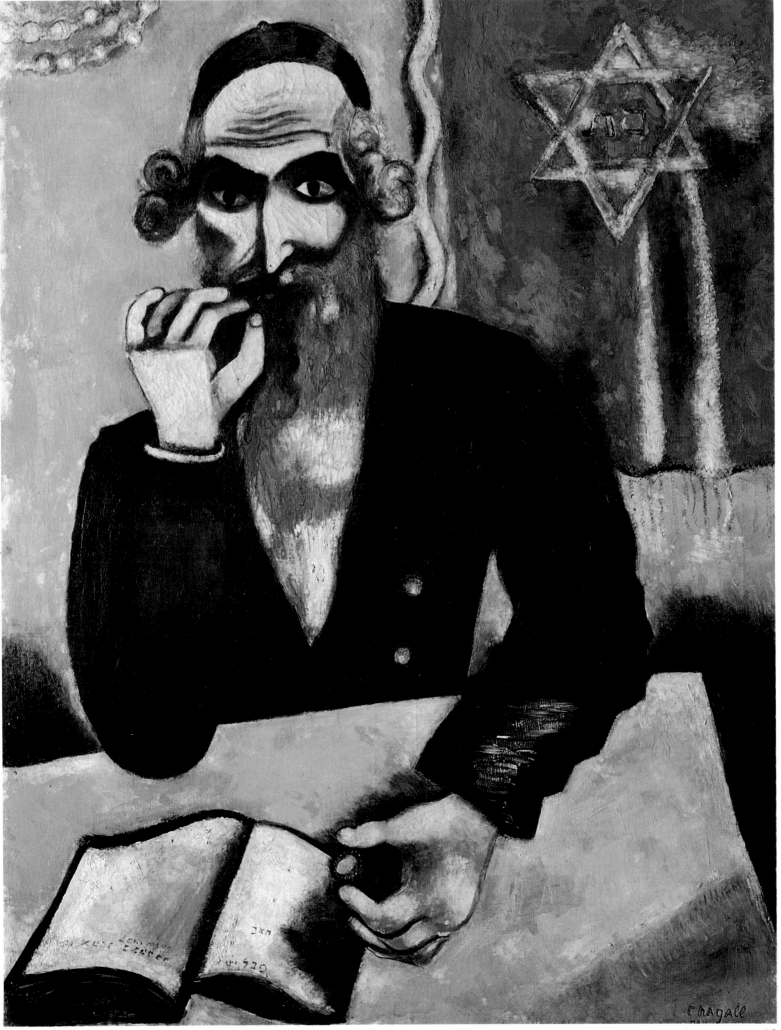

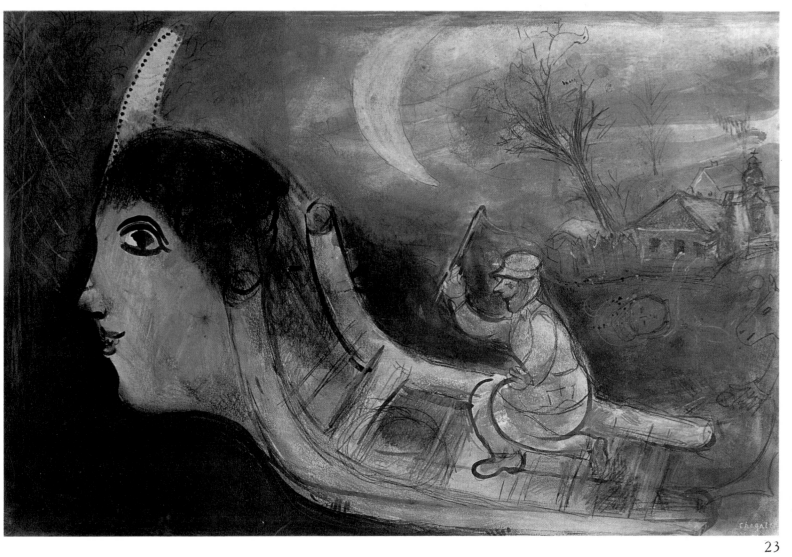

23

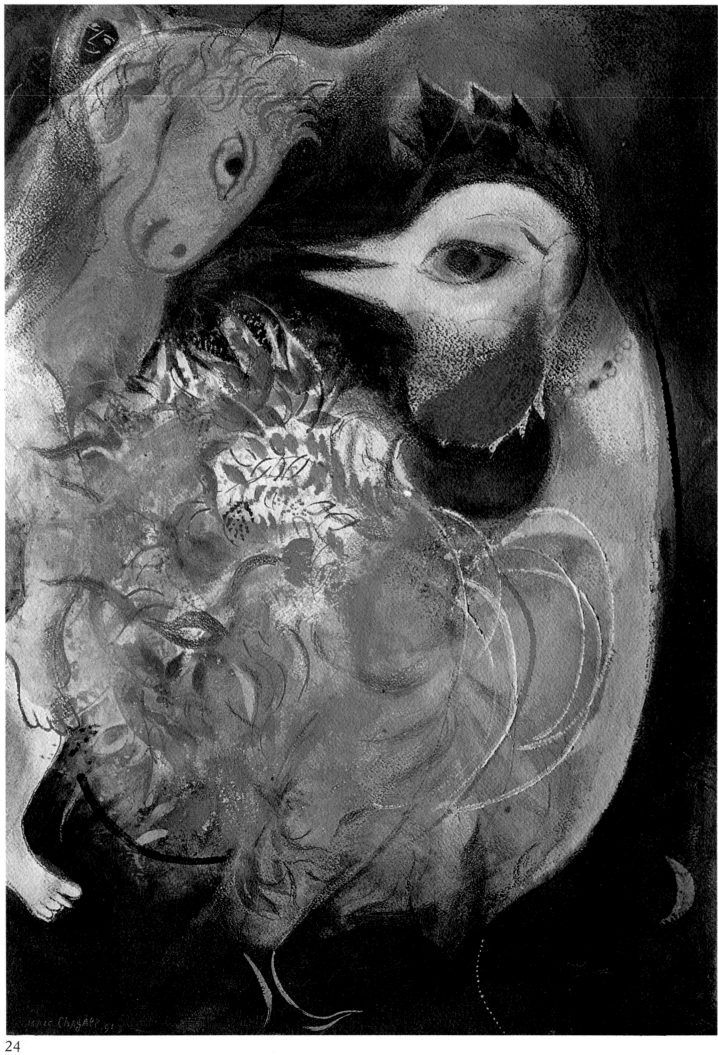

24

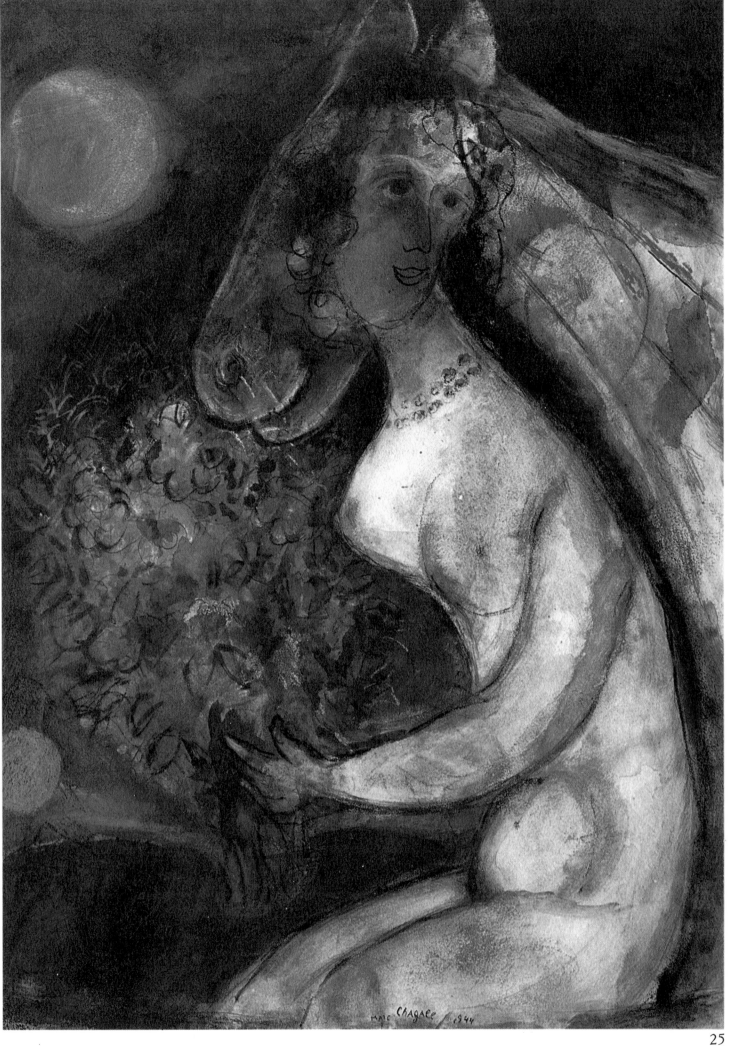

25

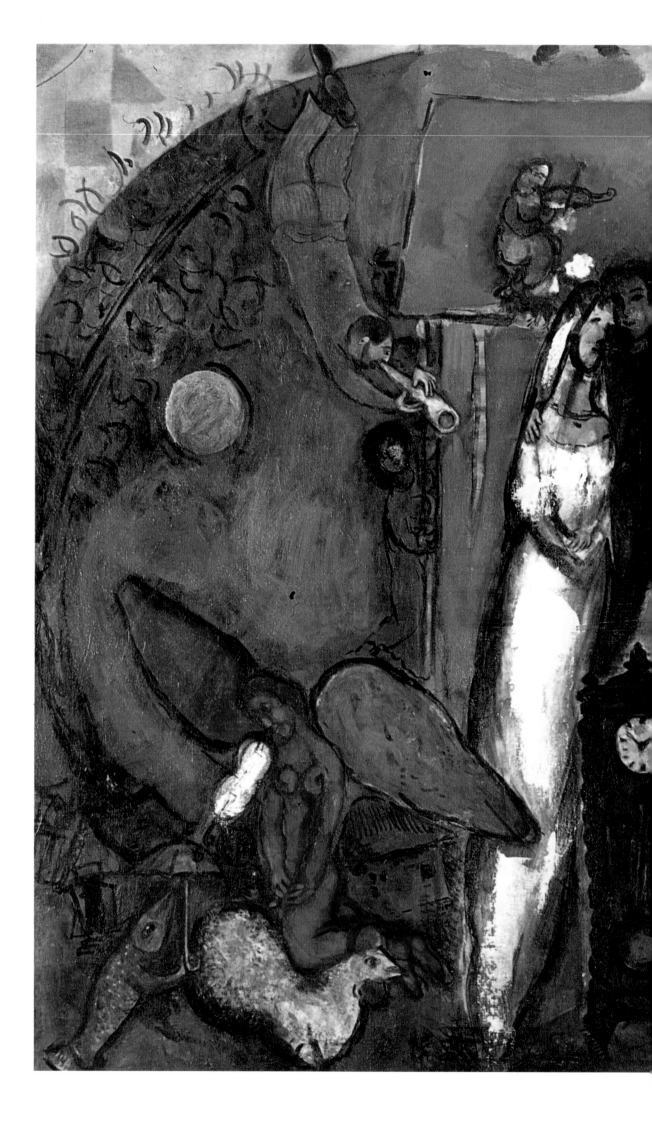

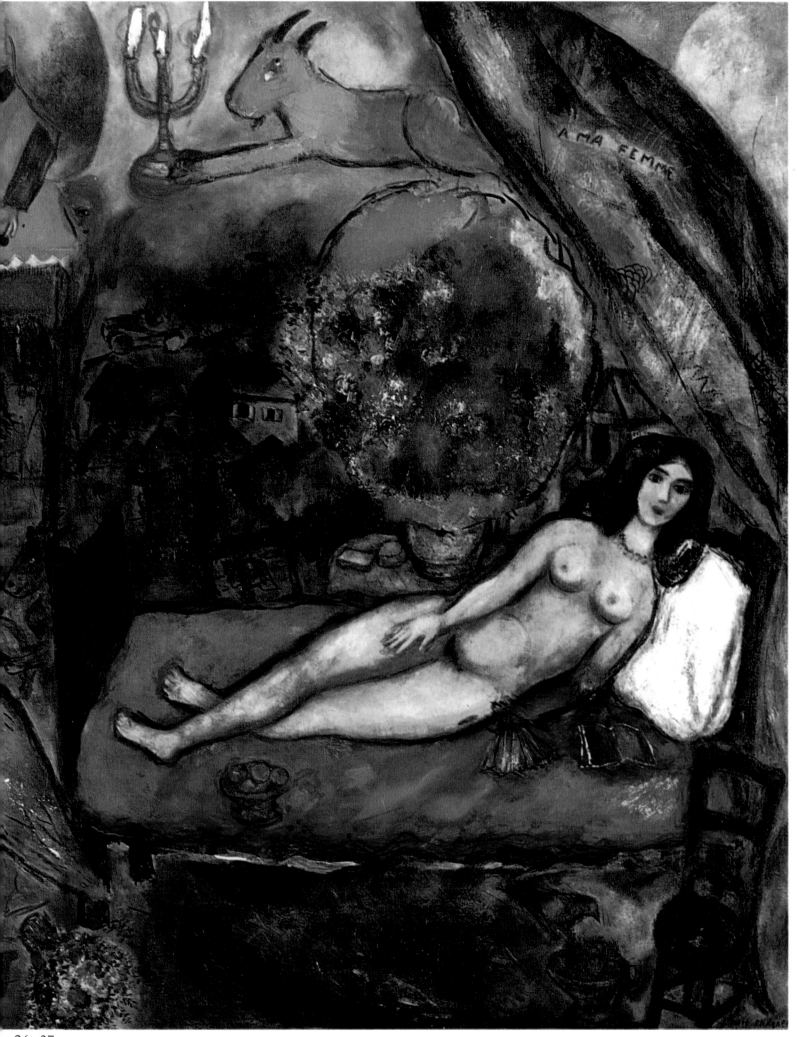

26-27

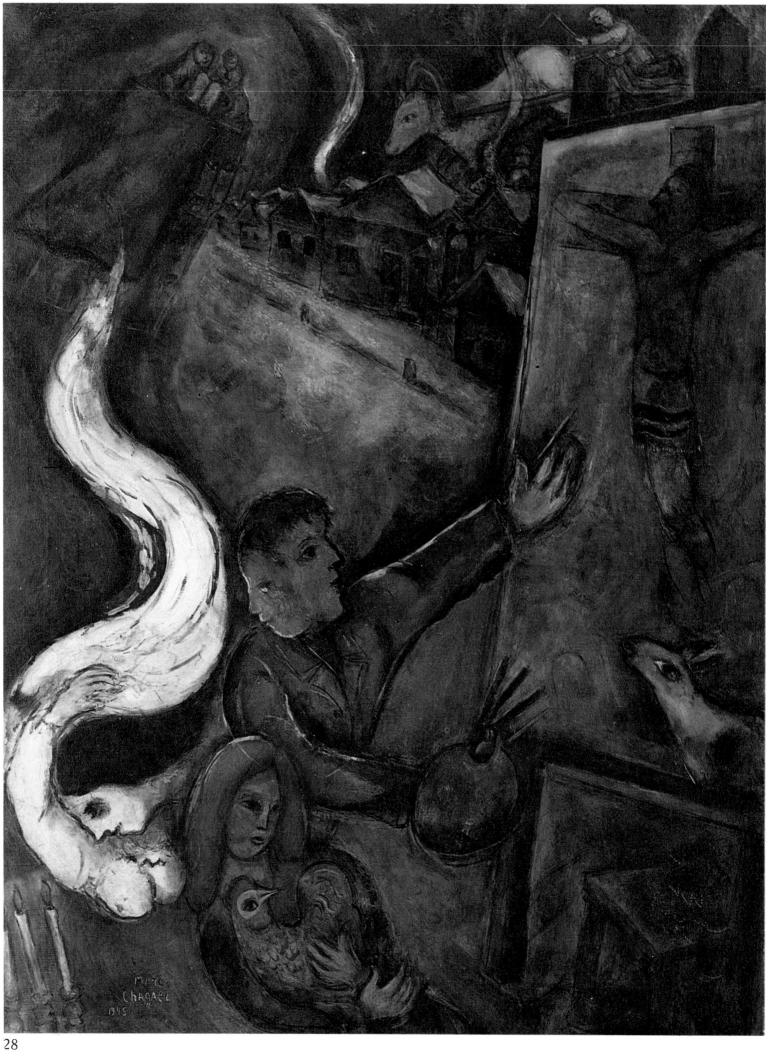

28

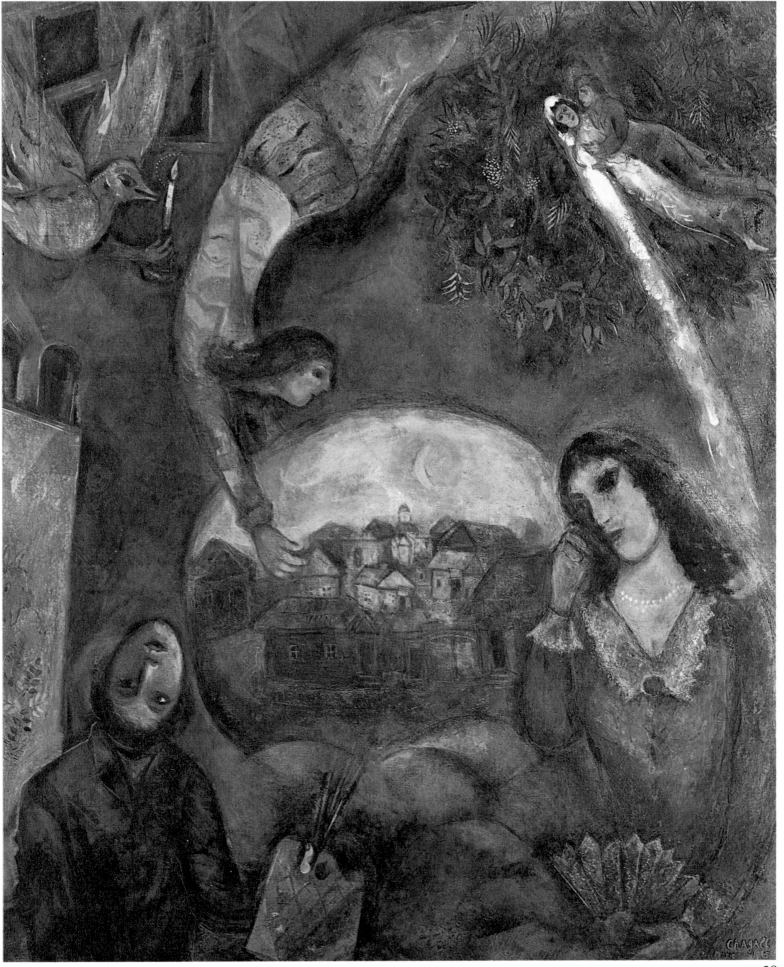

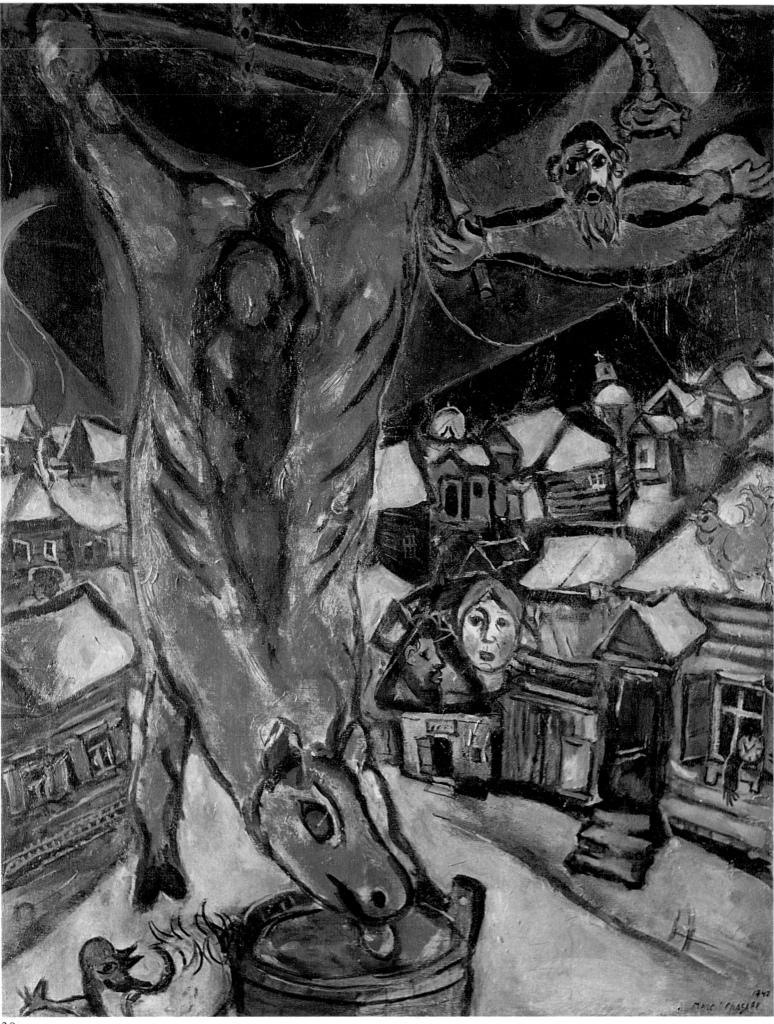

30

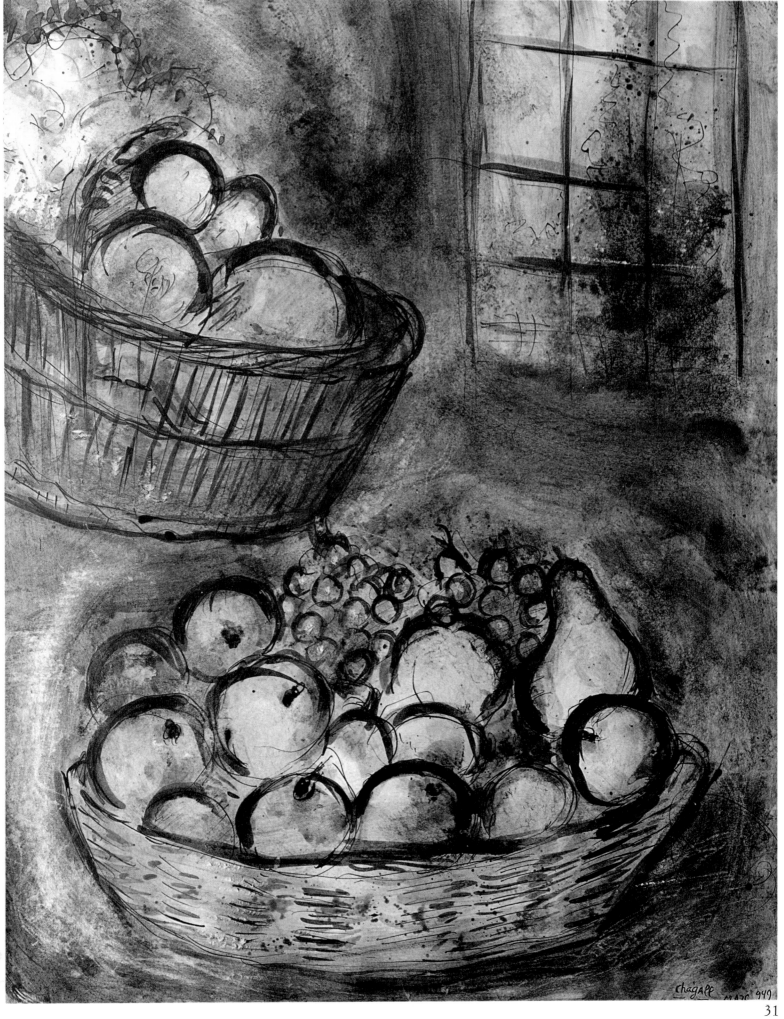

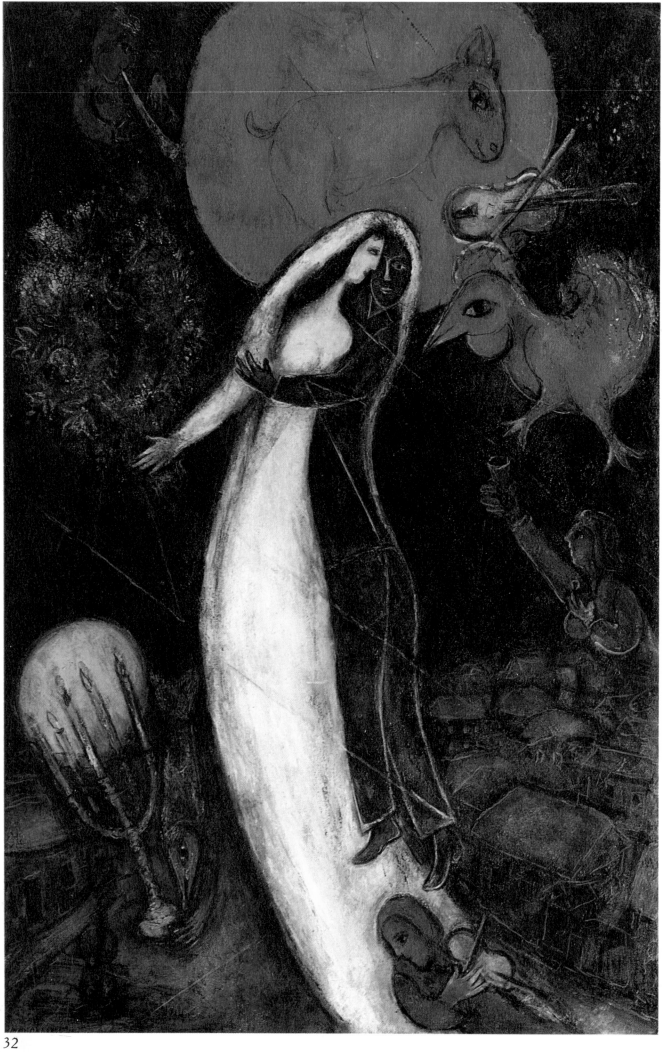

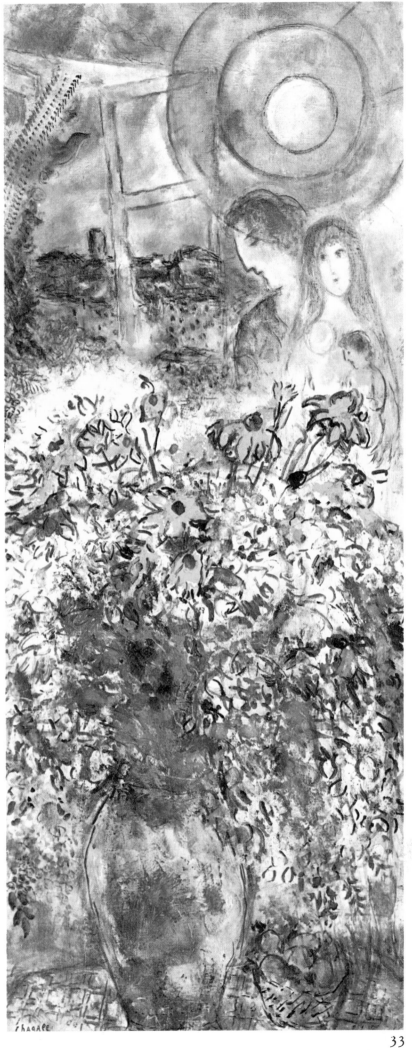

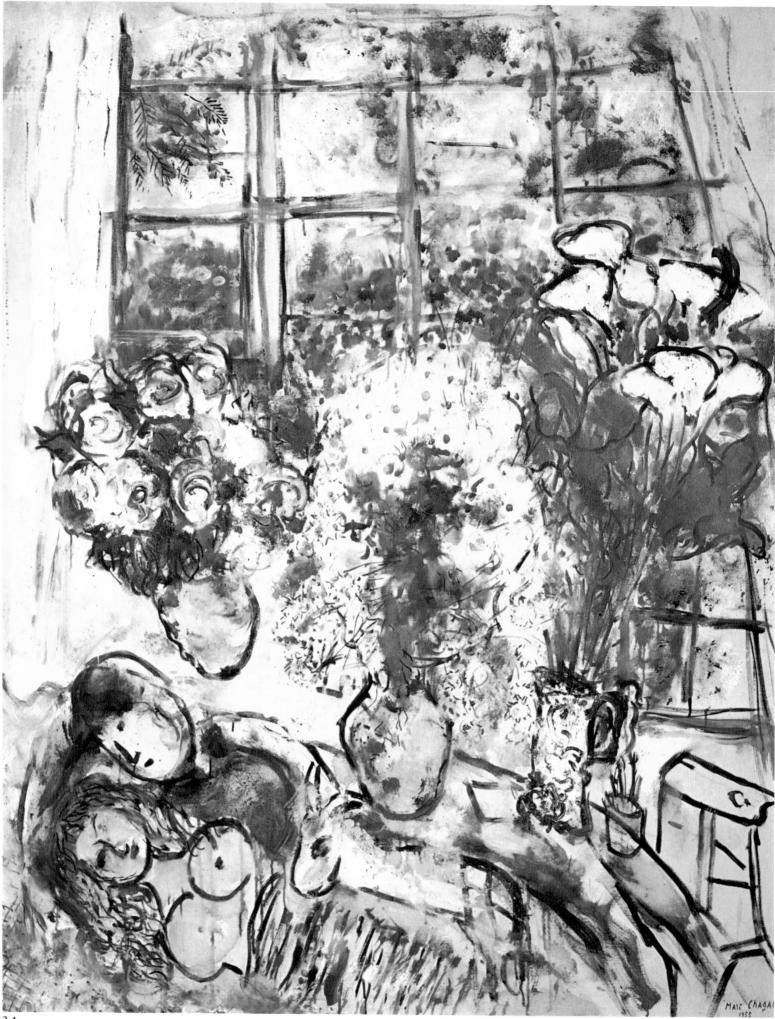

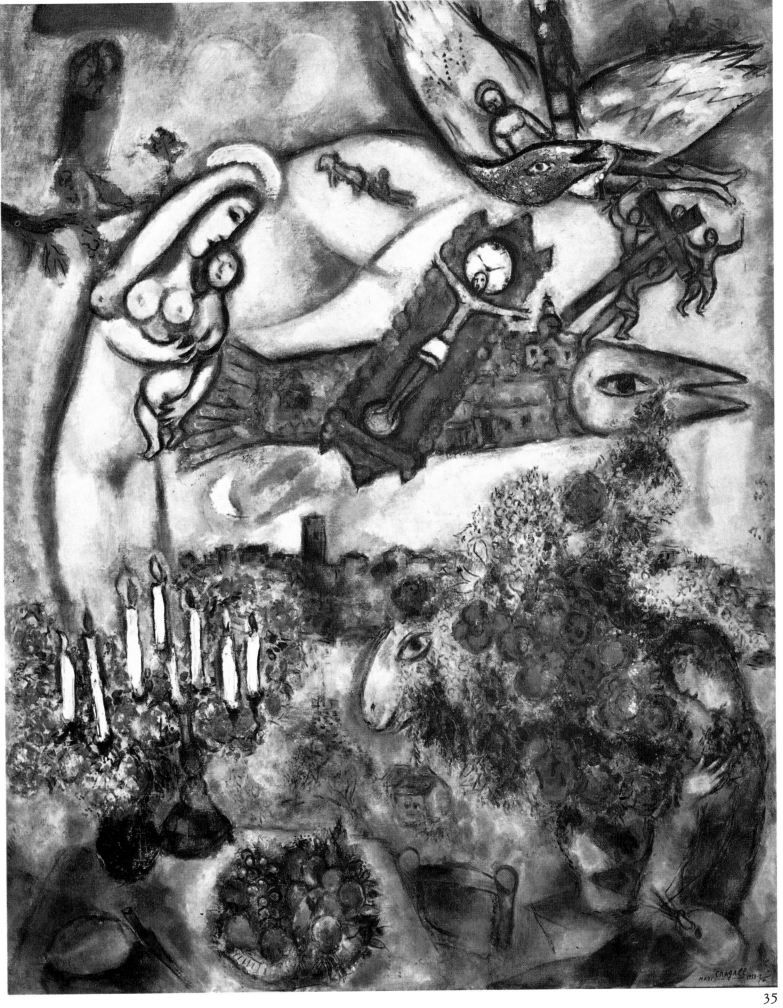

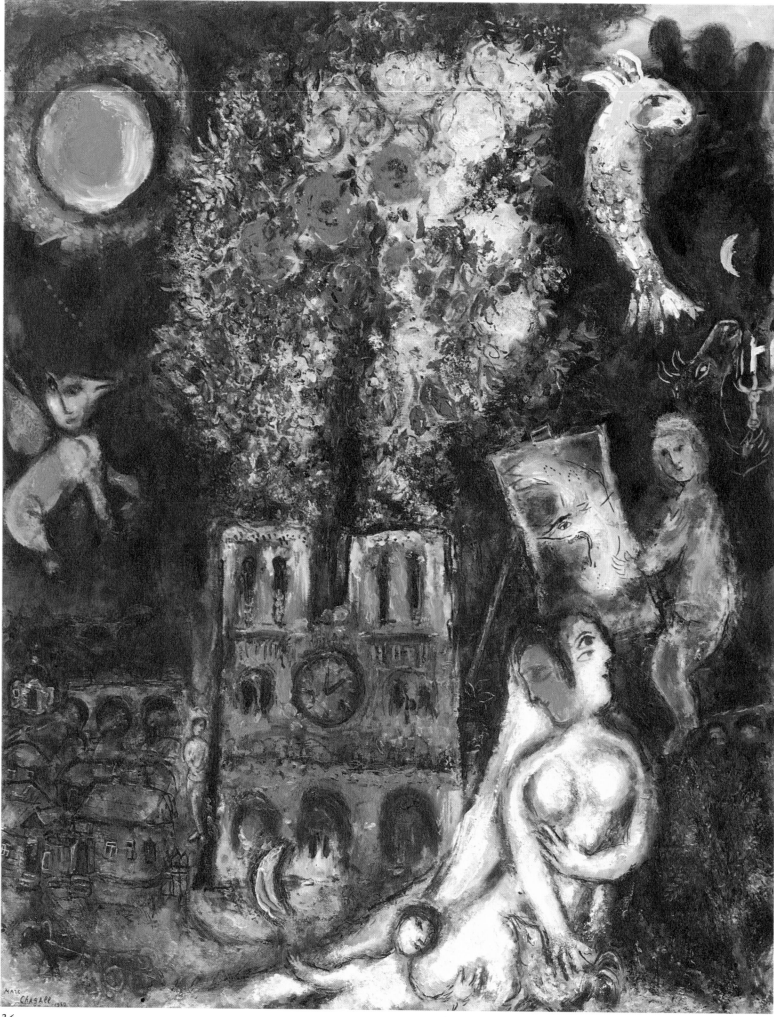

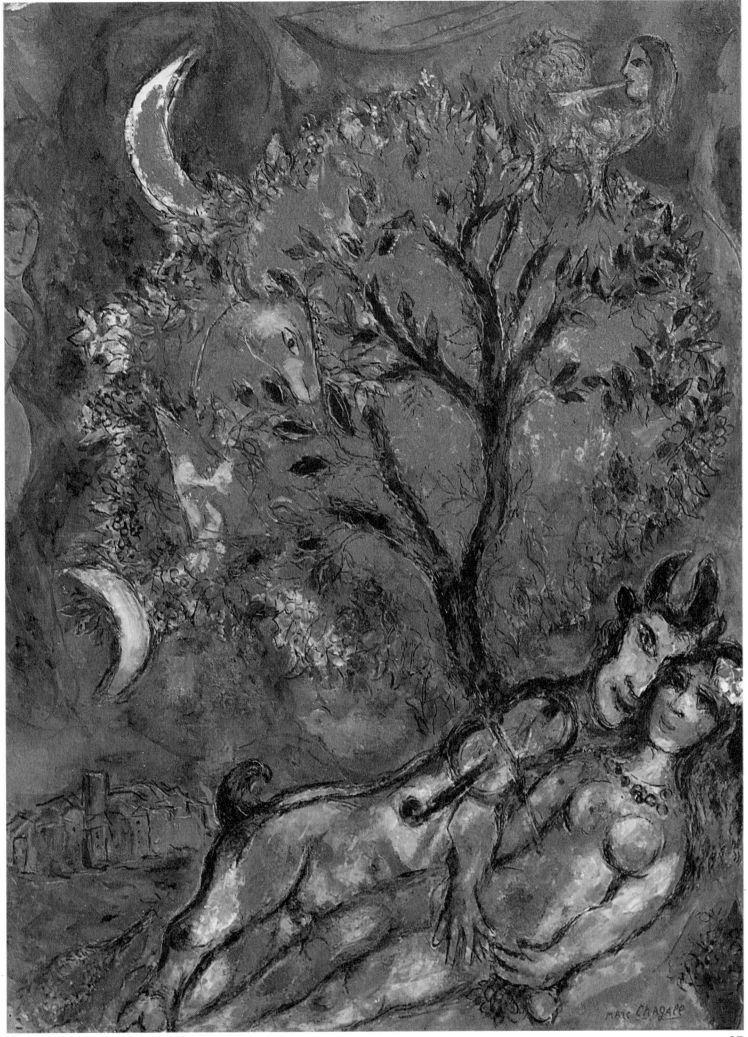

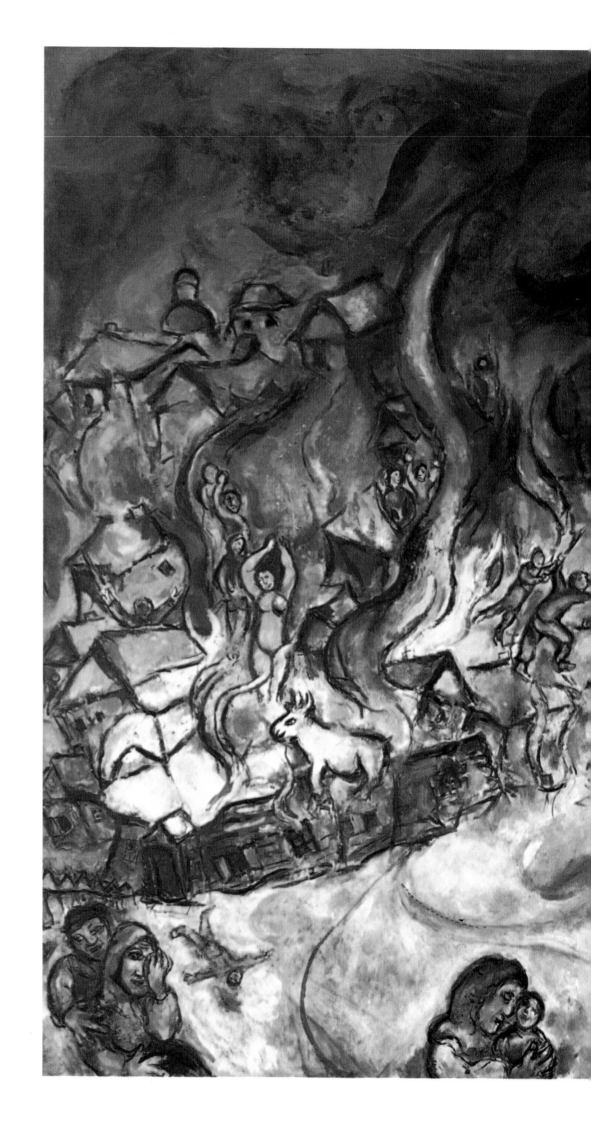

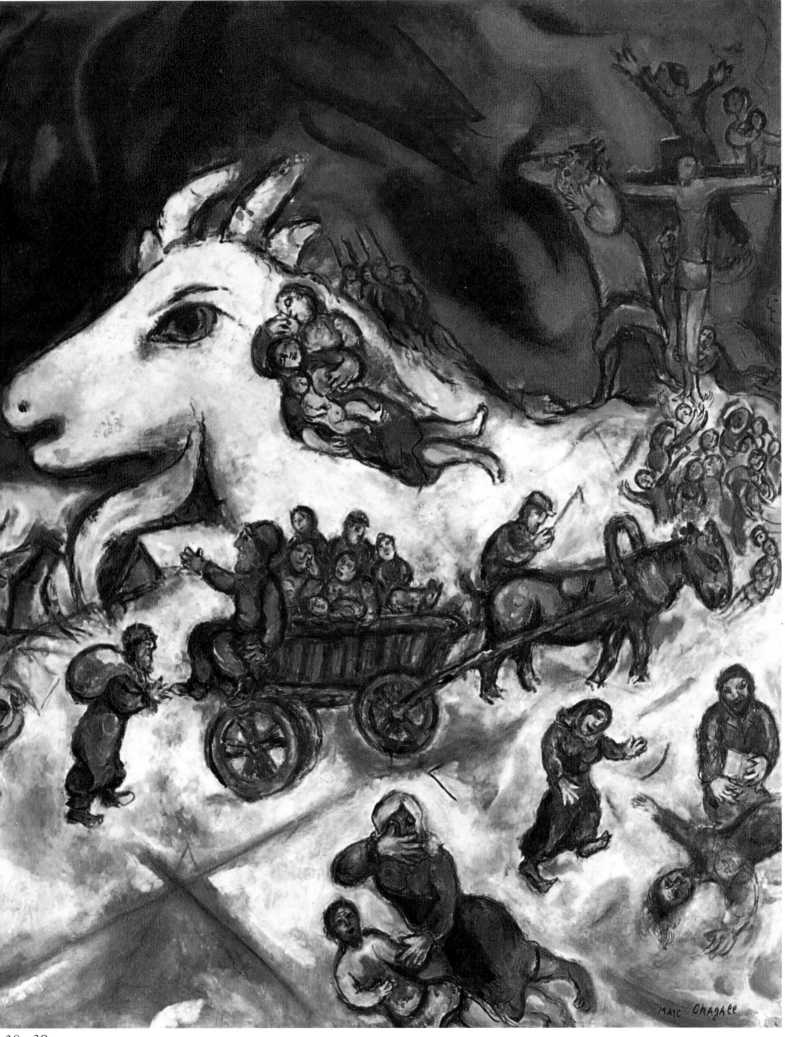

38—39

Marc Chagall

Description of colour plates

1 *My Fiancée in Black Gloves*
1909, oil on canvas, $34\frac{5}{8} \times 25\frac{5}{8}$ in (88 × 65 cm)
Offentliche Kunstsammlung, Basel

2 *To Russia, Asses and Others*
1911, oil on canvas, $61\frac{1}{2} \times 48$ in (156 × 122 cm)
Musée National d'Art Moderne, Paris

3 *Homage to Apollinaire*
1911–12, oil on canvas, $42\frac{1}{2} \times 78$ in (109 × 198 cm)
Stedelijk van-Abbe Museum, Eindhoven

4–5 *The Horse and Cattle Dealer*
1912, oil on canvas, $37\frac{3}{4} \times 78\frac{3}{4}$ in (96 × 200 cm)
Offentliche Kunstsammlung, Basel

6 *Winter*
1911–12,
Offentliche Kunstsammlung, Basel

7 *The Soldier is Drinking*
1912, oil on canvas, $41\frac{1}{4} \times 37\frac{3}{8}$ in (110 × 95 cm)
Guggenheim Museum, New York

8 *Self Portrait with Seven Fingers*
1912–13, oil on canvas, $50\frac{3}{8} \times 42\frac{1}{8}$ in (128 × 107 cm)
Stedelijk Museum, Amsterdam

9 *The Man in the Snow*
1913, oil on paper, $16\frac{1}{8} \times 12$ in (41 × 31 cm)
Musée National d'Art Moderne, Paris

10 *The House is on Fire*
1913, oil on canvas, $42\frac{1}{8} \times 47\frac{1}{4}$ in (107.2 × 120.5 cm)
Guggenheim Museum, New York

11 *Paris at the Window*
1913, oil on canvas, $42\frac{1}{8} \times 54\frac{7}{8}$ in (132.7 × 139.2 cm)
Guggenheim Museum, New York

12 *The Newspaperman*
1914, oil on canvas, $38\frac{9}{16} \times 30\frac{3}{4}$ in (98 × 78.5 cm)
private collection, Berne

13 *Holiday*
1914, oil on cardboard, $39\frac{3}{8} \times 31\frac{1}{2}$ in (100 × 80.5 cm)
Kunstsammlung Nordrhein-Westfalen, Düsseldorf

14 *Jew in Red*
1914, oil on cardboard stuck to canvas,
$39\frac{3}{8} \times 41\frac{1}{2}$ in (100 × 80 cm)
Charles Im Obersteg collection, Geneva

15 *Jew in Green*
1914, oil on cardboard, $39\frac{3}{8} \times 41\frac{1}{2}$ in (100 × 80 cm)
Charles Im Obersteg collection, Geneva

16 *The Stall*
1917, oil on canvas, $18\frac{5}{16} \times 24$ in (46.5 × 61 cm)
J. R. Belmont collection, Basel-Binningen

17 *The Window on the Island of Brehat*
1924, oil on canvas, $39 \times 30\frac{3}{4}$ in (99 × 73 cm)
Gustave Zunisteg collection, Zürich

18 *Maternity*
1925, oil on board,
Musée National d'Art Moderne, Paris

19 *The Reading*
1923–26, oil on canvas, $46\frac{1}{16} \times 33\frac{1}{4}$ in (117×89.5 cm)
Offentliche Kunstsammlung, Basel

20 *The Church of Chambon*
1926, gouache on paper, $25\frac{9}{16} \times 24$ in (65×61 cm)
Boymans van Beumingen Museum, Rotterdam

21 *The Butcher*
1928–29, gouache on paper, $25\frac{9}{16} \times 32\frac{7}{8}$ in (65×53 cm)
Kunsthaus, Zürich

22 *The Young Acrobat*
1930, oil on canvas, $25\frac{9}{16} \times 32\frac{1}{2}$ in (65×52 cm)
Musée National d'Art Moderne, Paris

23 *The Toboggan*
1943, watercolour and pastel on paper,
$32\frac{1}{16} \times 29$ in (51×76 cm)
private collection, Berne

24 *Les Plumes en Fleurs*
1943, gouache and pastel on paper,
$31\frac{1}{8} \times 33\frac{5}{8}$ in (79×55 cm)
Musée National d'Art Moderne, Paris

25 *Moonlight*
1944, gouache and pastel on paper,
$31\frac{1}{8} \times 20$ in (79×57 cm)
Musée National d'Art Moderne, Paris

26–27 *To my Wife*
1933–44, oil on canvas, $51\frac{9}{16} \times 76\frac{3}{8}$ in (131×194 cm)
Musée National d'Art Moderne, Paris

28 *The Soul of the City*
1945, oil on canvas, $42\frac{1}{8} \times 32$ in (107×81.5 cm)
Musée National d'Art Moderne, Paris

29 *All Around Her*
1945, oil on canvas, $59\frac{1}{16} \times 43$ in (150.9×109.7 cm)
Musée National d'Art Moderne, Paris

30 *The Flayed Ox*
1947, oil on canvas, $39\frac{3}{4} \times 31\frac{7}{8}$ in (101×81 cm)
private collection, Paris

31 *Still Life*
1949, gouache on paper,
Musée National d'Art Moderne, Paris

32 *The Wedding*
1947–51, oil on canvas, $54\frac{3}{4} \times 36\frac{1}{4}$ in (139×92 cm)
Colomba d'Oro collection, St Paul de Vence

33 *The Sunflowers*
1955, oil on canvas, $57\frac{7}{8} \times 23\frac{5}{8}$ in (147×60 cm)
Galerie Maeght, Paris

34 *The White Window*
1955, oil on canvas, $58\frac{15}{16} \times 47$ in (150×119.5 cm)
Offentliche Kunstsammlung, Basel

35 *Around Vence*
1955, oil on canvas, $63\frac{3}{8} \times 12\frac{3}{16}$ in (161×31 cm)
Galerie Maeght, Paris

36 *The Tree of Jesse*
1960, oil on canvas, $58\frac{15}{16} \times 47\frac{1}{4}$ in (150×120 cm)
Offentliche Kunstsammlung, Basel

37 *Red Tree*
1966, oil on canvas
Galerie Maeght, Paris

38–39 *War*
1964–66, oil on canvas, $64\frac{3}{16} \times 90\frac{15}{16}$ in (163×231 cm)
Kunsthaus, Zürich

40 *Blue Face*
1967, oil on canvas,
Galerie Maeght, Paris

Biographical outline

1887. Born July 7 in Vitebsk, Russia, into a Jewish working-class family.

1907. Begins to study painting under Pen in Vitebsk.

1907-10. Studies painting in St Petersburg, first at the Imperial Society for the Encouragement of the Arts, later at the School of Elizabeth Svanseva.

1910. Arrival in Paris and introduction into the city, and into a circle of contemporary poets and painters. He is patronised by Vinaver who offers him a subsidy for four years.

1912. Discovery of the Fauves and Cubists; is briefly touched by Futurism. Gets to know Braque, Picasso, Delaunay, Léger, Marcoussis, Segonzac, Archipenko, Sterenberg, Soffici, and Modigliani. Has his first studio in Rue de la Ruche and meets the poets Cendrars and Apollinaire. Exhibits for the first time at the Indépendants.

1914. First personal show in Berlin, organised by Walden, he sets up home for some time in that city. Returns to Vitebsk at the outbreak of war.

1915. Marries Bella Rosenfeld and settles in Vitebsk.

1918. Is nominated Commissioner for Fine Arts in Vitebsk.

1919. Is nominated Director of the Academy of Vitebsk, in which Malevic the Suprematist also teaches.

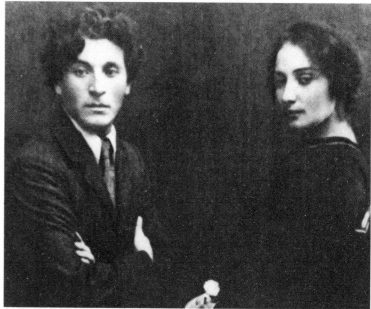

1920. Resigns from Directorship of the Academy and leaves for Moscow. Here he does stage decors and painted wall panels for the Jewish Theatre.

1921. Teaches painting to war orphans in a Moscow suburb.

1922. Writes *My Life* in French, assisted by Bella, making use of notes made earlier in Russia. Returns to Berlin when life in his own country becomes impossible after being told that he was not suited to politics and the realities of Marxist socialism.

1923. Returns to France and meets the publisher Vollard, through whom he receives commissions to illustrate various publications. He meets Eluard, Ernst and Gala who want him to join the Surrealist movement. He refuses.

1924. Illustrates Gogol's *Dead Souls,* which is not published until 1948.

1926. Again commissioned by Vollard, he starts a series of etchings for the *Fables* of La Fontaine, which were eventually published in 1952.

1930. Begins a more private domestic style of life, moving to Villa Montmorency, near the Porte d'Auteuil. Travels frequently to Switzerland to rediscover countryside like that of Russia.

1931. Begins etchings for the Bible, which were finally published in 1956, and is invited to Palestine where he goes to seek inspiration for his Bible illustrations.

1939. Receives the Carnegie Prize.

1940. Vollard dies. Chagall meets Tériade.

1941. Because of the war and racial discrimination he leaves France and embarks at Lisbon for the United States where he has been invited to settle.

1942. The beginning of his American stay. He travels to Mexico and prepares the scenery and costumes for *Aleko*.

1944. Bella dies. For nine months he does no work, occupying himself solely with bringing out Bella's writings under the title *Lighted Lamps*.

1945. Starts work again with scenery and costumes for Stravinsky's *Firebird* for presentation by the Ballet Theatre of New York.

1946. Selected exhibition at the Museum of Modern Art, New York.

1947. Exhibition at the Musée National d'Art Moderne, Paris. First colour lithographs.

1948. Triumphant return to Paris. Renews contact with Tériade who from then on acts as his publisher.

1950. Settles in Vence, Provence. First attempts at painting and modelling ceramics.

1951. First stone sculptures.

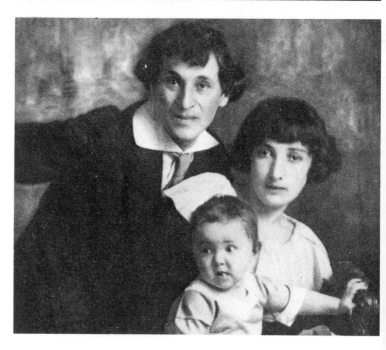

36 Chagall (top left) with his parents and sisters

37 Chagall and Bella in 1910

38 Chagall and Bella with their daughter Ida in 1917

39 Chagall at St Paul de Vence in 1969

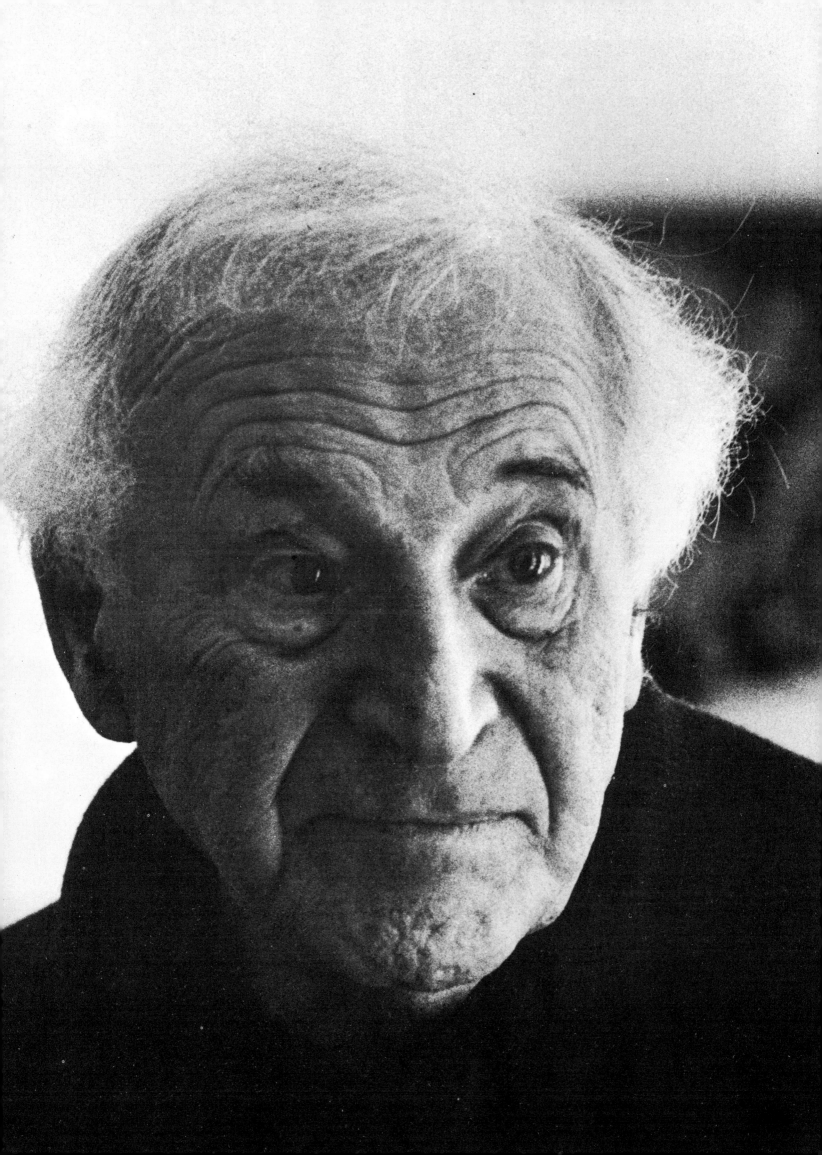

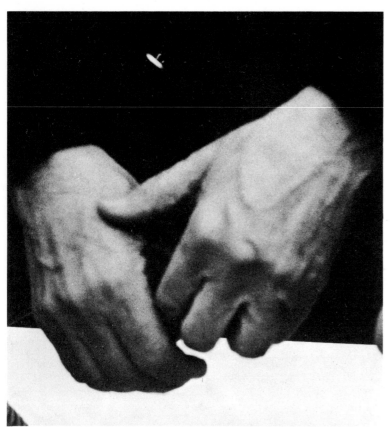

1952. Meets Valentine Brodsky (Vava) and marries her. Travels with her to Greece.

1957. Executes his first mosaics.

1958. Does scenery and costumes for the ballet *Daphnis and Chloé* for the Paris Opera.

1960. Completes the windows (lancets and roses) for the Gothic cathedral of Metz.

1961. Does the windows for Hadassah Synagogue, near Jerusalem.

1963. Supplies the cartoons and follows the working of his first tapestries which are to decorate the Parliament of Israel in Tel Aviv.

1964. At Malraux's invitation he paints the panels which are to be fixed to the Opera ceiling in Paris.

1966. Executes two huge panels for the Lincoln Centre, New York. Moves from Vence to St Paul de Vence where he still lives.

1967. Designs scenery and costumes for *The Magic Flute*. Has a vast exhibition at the Louvre.

1969–70. A comprehensive exhibition opens at the Petit Palais of all of Chagall's work: paintings, gouaches, sculpture, ceramics, stained glass, tapestries and sketches for theatrical scenery and costumes.

40 Chagall's hands

41 Chagall with Mario Bucci at St Paul de Vence

Bibliography

WORKS BY CHAGALL

Ma Vie, translated from the Russian by Bella Chagall, preface by André Salmon, with 32 early drawings by the author, Paris, 1931; *Ma Vie*, 2nd edition, preface by Georges Charensol with 31 drawings and 14 water-colour prints; *La Mia Vita*, Italian edition, Il Saggiatore, Milan, 1960; *The Future* (in Yiddish), No. 30, pp. 158-162, 211-214, 290-293, 407-410, New York, March-June 1955; 'Art on the Anniversary of the October Revolution' (in Russian), *Vitebsky Listok*, No. 1030, Vitebsk, November 7, 1918; 'Letter from Vitebsk' (in Russian), *Iskustvo Komuni* No. 3, pp. 2-3, Petrograd December 23, 1918; 'Reflections on Art' (in Russian) *Vitebsky Listok*, No. 1091, Vitebsk, January 8, 1919; 'Reflections on the People's Academy of Fine Arts in Vitebsk' (on the occasion of the first show by pupils of Chagall, in Russian), *Schkola Revoluzia*, No. 24-25, pp. 7-8, Vitebsk, August 16, 1919; 'The Revolution in Art' (in Russian), *Revoluzionnoje Iskustvo*, No. 1, pp. 2-3, Vitebsk, 1919; Introduction to the catalogue of the 40 works shown at the Exhibition of the League of Culture in Moscow, April 1922; Georges Charensol, 'Chez Marc Chagall', interview published in *Paris-Journal*, May 16, 1924; 'My First Teacher: Pen' (in Russian), *Razsviet*, Paris, January 30, 1927; 'My Work in the Jewish Theatre of Moscow' (in Yiddish), *Di Idisze Welt*, Wilno, 1928; A. Prevanne, 'Folklore in the Art of Chagall', interview published in *Monde*, 3, No. 113, p. 8, Paris, August 2, 1930; 'Modern Art', lecture (in Hebrew) *Moznayim*, Nos. 46-47, pp. 14-15, No. 48, pp. 12-13, Tel-Aviv, March-April 1931; 'My Journey to Palestine', *L'Intransigeant*, Paris, May 3, 1932; 'My Journey to Holland', *L'Intransigeant*, Paris, June 8, 1931; 'Answer to the question: "can you say what has been the most important meeting in your life?"', *Minotaure*, No. 3-4, p. 106, Paris, 1933; 'Answer to our inquiry: "On the Crisis in Painting"', *Beaux Arts*, Brussels, August 19, 1935; 'Answer to the inquiry: "what do artists think of the Exhibition of Italian Art?"', *Bête-Noir*, Paris, October 1935; 'Answer to the question: "What about the art of today?"', *Cahiers d'Art*, Nos. 1-4, pp. 37, 39-44, Paris, 1935; 'Response to a Beaux Arts Inquiry into "The Profession of the Artist"', *Beaux Arts*, No. 196, Paris, October 1936; *Chronology, 1889-1941*, New York, 1941; 'Letter to French Painters', *Le Spectateur des Arts*, No. 1, p. 3, Paris, December 1944; 'Some Impressions of French Painting', meeting at Mount Holyoke College, August 1943, *Renaissance*, Trimestrial Revue of the Free School of Higher Studies, New York, vols II/III, pp. 45-57, New York, 1944-45; 'The Art of Rectitude and Clarity', *Naje Lebn*, XVIII, No. 6, New York, June 1945; conference held on an evening organised by ICOR in honour of Marc Chagall and Itsik Feffer, April 30, 1944; 'The child is free to see a magical world', *Arts*, p. 12, Paris, May 29-June 4, 1953; 'Homage to Matisse', *The Yale Library Magazine*, Yale 1955; 'Emergence from Realism', thoughts collected by Yvon Taillandier, *XXth Century*, No. 2, Paris, March 15, 1959; *Lithographs*, illustrated catalogue of his lithographic work with a foreword by Chagall, Paris, 1960.

WORKS ILLUSTRATED BY CHAGALL

Neue Europaische Graphik, Italian and Russian artists (Bauhaus editions, 4), Muller & Co., Potsdam, 1921; MARC CHAGALL, *Mein Leben*, 20 engravings, portfolio of 20 etchings and *puntesecche*, 110 numbered copies, Berlin, 1923; *L'Album des Peintres Graveurs*, Album No. 3, Ambroise Vollard, Paris, 1924, not published. (Contains the etching of the Acrobat with Violin. The album should also have contained original graphic works by Bonnard, Cézanne, Forain, Leheutre, Lunois, Renoir, Signac, Vallotton and Vuillard.) *Les Peintres-Graveurs indépendants*, ed. Albert Morance, Paris, 1925 (115 copies with 5 original etchings); MARCEL ARLAND, *Maternité*, poems decorated with 5 separate engravings by Marc Chagall, Au Sans-Pareil, Paris, 1926; 5 etchings, 960 numbered copies; *Les sept péchés capitaux*, text by Jean Giraudoux, Paul Morand, Pierre MacOrlan, André Salmon, Max Jacob, Jacques de Lacretelle and Joseph Kessel, Simon Kra, Paris, 1926; 15 etchings; PAUL MORAND, *Ouvert la nuit*, 120 numbered copies contain 1 etching as a frontispiece, *Nouvelle Revue Française*, Paris, 1927; ANDRÉ SALMON, 'Chagall' (The New Masters, 4) 60 numbered copies contain the etching as frontispiece, ed. *Les Chroniques du Jour*, Paris, 1928; PAUL FIERENS, 'Marc Chagall', ed. *La Revue d'Art*, Antwerp, 1929; LIONELLO VENTURI, *Marc Chagall*, 50 numbered *de luxe* copies contain 1 etching, *Offering*, as frontispiece. (The etching is in black and white in numbers I-XX, in the others is coloured by the artist, Pierre Matisse.) New York, 1945; 'Arabian Nights', original coloured lithographs by Marc Chagall, for *Four Tales of the Arabian Nights*, Pantheon Books, New York, 1948 (12 original lithographs in colour, printed by A. Carman in collaboration with the artist. Every engraving signed Chagall); NICOLAS GOGOL, *Dead Souls*, translated by Henry Mongault, Tériade, Paris, 1948; ILIAZD (Ilva Zdanevich), *Poésie de mots inconnus*, poetry by Arp, Ball, Birot, Bryen, Dermée, Hausmann, Huidobro, Iliazd, Jolas, Picasso, Schwitters, Seuphor, Tzara and others, *Le Degré*, 41, Paris, 1949; Robert Rey, 'Estampes', ed. *l'Image littéraire*, Rafael Finalli Feugère, Paris-Nice-New York, 1949; *Verve*, Revue artistique et littéraire, Marc Chagall, *La Bible*, Nos. 33-34, special edition of Verve with texts by Meyer Shapiro and Jean Wahl, *L'Ecriture est Gravure*, reproductions of 105 engravings for the Bible, ed. review *Verve*, Paris, 1956; *Derrière le miroir*, Nos. 99-100, special Marc Chagall edition published for his exhibition 'Paintings 1955-1957', text by Jean Paulhan, 'Chagall a

sa juste place', with 3 drawings and 3 original lithographs in colour (one on the cover), Maeght edition, Paris, 1957; JACQUES LASSAIGNE, *Chagall*, with 13 original lithographs in colour and 2 in black and white, Maeght edition, Paris, 1957; *XXème*, art notebooks published under the direction of G. di San Lazzaro, No. 9, 1 original lithograph in colour, Paris, 1957; *Derrière le miroir*, Nos. 107-109, special edition *Sur 4 murs*, 1 original lithograph in colour, Maeght edition, Paris, 1958; JEAN PAULHAN, *De mauvais sujets*, original coloured etchings, Les bibliophiles de l'union française, Paris, 1958; Catalogue of the Marc Chagall exhibition at the Musée des Arts Décoratifs, 350 *de luxe* numbered copies, with 1 original lithograph, numbered and signed by the artist, Paris, 1950; *Chagall lithographe*, text by Julien Cain, with a foreword by Chagall and notes by Fernand Mourlot, 12 original lithographs (one on the cover), Paris, 1960; *Derrière le Miroir*, No. 119, special edition, *Poets, painters, sculptors*, with 1 coloured lithograph, Maeght edition, Paris, 1960; *Derrière le Miroir*, Nos. 121-122, with 1 lithograph in colour on the cover, Maeght edition, Paris, 1960; *Verve*, literary and artistic review, Nos. 37-38, *Marc Chagall, drawings for The Bible*, special edition of *Verve*, with text by Gaston Bachelard, 'Introduction à la Bible de Chagall', contains reproductions of 96 drawings for the Bible and 24 original lithographs in colour and a coloured drawing on the cover, *Verve* review edition, Paris, 1960; LONGUS, *Daphnis et Chloe*, with 42 original lithographs by Marc Chagall, Tériade, Paris, 1961.

WORKS ON CHAGALL

BLAISE CENDRARS, *Marc Chagall–Atelier*, poetry dedicated to Chagall, dated October 1913, first published in *Der Sturm*, 4, Nos. 198-199, p. 183, Berlin, February 1914, reprinted in *Dix-neuf poèmes élastiques*, Paris 1919, pp. 12-16; GUILLAUME APOLLINAIRE, *Rotsoge: au peintre Chagall*, poetry written for the exhibition of Chagall at the gallery Der Sturm, Berlin, 1914, first published in *Der Sturm*, Berlin 5, No. 3, May 1914, and with various modifications, under the title 'A travers l'Europe', in *Calligrammes*, Paris, 1918; CANUDO, 'Chagall', *Paris-Journal*, Paris, July 11, 1914; ANDRÉ SALMON, 'Le XXXe Salon des Artistes Indépendants', *Montjoie*, 2, No. 3, Paris, March 1914; A. M. EFROSS, 'Critique of the exhibition held at the Salone d'Arte Michailowa, exhibition of the year 1915 (Russian text), *Russkije Vjedomostij*, No. 70, Moscow, March 28, 1915; J. Tugendhold, 'A New Talent' (Russian text), *Russkije Vjedomostij*, No. 71, Moscow, March 29, 1915; A. M. EFROSS, 'Marc Chagall' (Russian text), *Novij Pout*, Nos. 48-49, Moscow, December 18, 1916; A. M. EFROSS, 'The Exhibition of "Faute di Zuadri"' (Russian text), *Russkije Vjedomostij*, No. 258, Moscow, November 8, 1916; ANDRÉ LEVINSON, 'Notes on an Exhibition' (Russian text), *Letopis*, No. 5, Leningrad, 1916; ANDRÉ LEVINSON, 'Exhibitions of contemporary Russian art' (Russian text), *Istkustvo*, Nos. 4-5, Leningrad, 1916; L. N., 'Exhibitions of Contemporary Russian Art' (Russian text), *Birjovije Vjedomostij*, No. 16012, Leningrad, December 31, 1916; N. N. PUNIN, 'Exhibitions of Contemporary Russian Art' (Russian text), *Severnije Zapiski*, No. 12, Leningrad, December 1916; J. TUGENDHOLD, 'Marc Chagall' (Russian text), *Apollon*, No. 2, pp. 11-20, Leningrad, February 7, 1916; ANDRÉ LEVINSON, 'The Contemporaries' (Russian text), *Letopis*, No. 1, Leningrad, 1917; A. EFROSS and J. TUGENDHOLD, *The Art of Marc Chagall* (Russian text), Gelikon, Moscow, 1918, 52, German edition, *Die Kunst Marc Chagalls*, Potsdam, 1921; A. EFROSS, 'Before the Curtain Goes Up', *Teatr i Musika*, No. 9, Moscow, 1922; *Sturm–Bilderbucher–I: Marc Chagall*, with the poems *Marc Chagall* by Blaise Cendrars, Berlin, 1922; ANDRÉ WARNOD, 'Le réalisme et la fantaisie dans l'oeuvre de Marc Chagall', *Comoedia*, Paris, December 15, 1924; FLORENT FELS, 'Les expositions: Marc Chagall' (Galerie des Quatre-Chemins), *Les Nouvelles Littéraires*, Paris, November 14, 1925; ANDRÉ LHOTE, 'L'Exposition Chagall' (Galerie Barbazanges-Hodebert), *Nouvelle Revue Française*, No. 137, Paris, November 1, 1925; GUIDO LODOVICO LUZZATO, 'Marc Chagall: Ma Vie', *Il Convegno*, Milan, December 1925; ANDRÉ SALMON, 'Marc Chagall', *L'Art vivant*, No. 22, Paris, November 15, 1925; S. PUTNAM, 'Marc Chagall', *The Chicago Evening Post Magazine*, Chicago, January 1926; E. TÉRIADE, 'Les sept péchés capitaux. Illustrés par Marc Chagall, *Cahiers d'Art*, No. 6, Paris, 1926; ALBERT DREYFUS, 'Marc Chagall', *Deutsche Kunst und Dekoration*, Darmstadt, February 1927; WALDEMAR GEORGE, 'Marc Chagall', *Das Kunstblatt*, Potsdam, January 1927; ISAAC LICHTENSTEIN, *Marc Chagall*, (monographs on Jewish artists, Yiddish text), ed. Le Triangle, Paris, 1927; ANDRÉ SALMON, 'Chagall', *La Revue de France*, Paris, January 1927; ANDRÉ SALMON, 'Chagall illustrateur' (Suite provinciale), *Paris-Matin*, Paris, July 4, 1927; A. EFROSS, 'The Painters of the Granovskij Theatre' (Russian text), *Istkustvo*, 1-2, Moscow, 1928; WALDEMAR GEORGE, 'Marc Chagall', ed. *Nouvelle Revue Française*, Paris, 1928; HILL GILLAND, 'Marc Chagall', *Mult es Zoro*, Budapest, January 1928; M. KAPLAN, 'Marc Chagall', *Chicago Evening Post*, Chicago, December 11, 1928; ANDRÉ SALMON, 'Chagall', ed. *Chroniques du Jour*, Paris, 1928; RENÉ SCHWOB, 'Chagall, peintre juif', *Amour de l'art*, 9, August 1928; VOJANSKIJ, 'Marc Chagall' (Russian text), *Krasnaja Panorama*, No. 47, Moscow, 1928; CHRISTIAN ZERVOS, 'Marc Chagall', *Drawing and Design*, 4, No. 19, January 19, 1928; PAUL FIERENS, 'Marc Chagall' (Etudes d'art contemporain), *Editions de la Revue d'Art*, Antwerp, 1929; JEAN SYLVERE, 'Portraits d'artistes: Chagall', *Cahiers d'Art*, 4, No. 5, Paris, 1929; DEBORAH VOGEL, 'Esthetic Essay on Marc Chagall (Yiddish text), *Gusztajer*, No. 1, Lwow, 1929; JEAN CASSOU, 'La Fontaine et Chagall', *Art vivant*, Paris, 1930; HUBERT COLLEYE, 'La Fontaine vu par Chagall', *Metropole*, Antwerp, March 9, 1930; P. DU COLOMBIER, 'La Fontaine et Chagall', *Candide*, No. 310, Paris, February 20, 1939; A. M. EFROSS, *Profiles: Marc Chagall* (Russian text), ed. Federatsija, Moscow, 1930; BENJAMIN FONDANE, 'Marc Chagall' (Russian text), *Cisla*, No. 1, Berlin, 1930; GUIDO LODOVICO LUZZATTO, 'Chagall', *Rassegna Mensile di Israel*, V, No. 2, Citta di Castello, June 1930; MAX OSBORN, '100 Fabeln von La Fontaine' (Exhibition at the Flechtheim Gallery), *Vossische*

Zeitung, Berlin, April 12, 1930; A. PREVANNE, 'Le Folklore dans l'Art de Marc Chagall', *Le Monde*, 3, No. 113, Paris, August 2, 1930; ANDRÉ DE RIDER, 'La Fontaine vu par Chagall', *Variétés*, 2, No. 10, Brussels, February 15, 1930; AMBROISE VOLLARD, 'J'édite les Fables de la Fontaine et je choisis Chagall comme illustrateur', preface to the catalogue of the exhibition 'La Fontaine par Chagall', Bernheim Jeune Gallery, Paris, 1930; CHRISTIAN ZERVOS, 'Les Fables de La Fontaine' (exhibition at the Bernheim Jeune Gallery), *Cahiers d'Art*, 5, No. 1, Paris, 1930; RAFAEL ALBERTI, 'Paris-Chagall', *El Sol*, Madrid, August 2, 1931; BLAISE CENDRARS, *Aujourd'hui* (text dated April 1912), Bernard Grasset, Paris, 1931; RENÉ SCHWOB, *Chagall et l'âme juive*, ed. Correa, Paris, 1931; HAROLD FRANKLIN, 'Marc Chagall, a wild beast of art', *Jewish Layman*, 7, No. 2, Cincinnati, 1932; GUIDO LODOVICO LUZZATTO, 'Notes sur Chagall a l'occasion de l'exposition Chagall à la Kunsthalle de Bâle', *Revue juive de Genève*, 2, No. 2, Geneva, November 3, 1933; GILLES DE LA TOURETTE, 'Marc Chagall', *L'Architecture d'Aujourd'hui*, No. 6, Paris, 1933; GERMAIN BAZIN, 'En marge du réel'; Marc Chagall', *Amour de L'Art*, No. 15, Paris, March 1934; ALEXANDER BENOIS, 'The return to subject matter' (Russian text), *Poslednija Novosti*, Paris, January 20, 1934; RAYMOND COGNIAT, 'Visite d'atelier: Marc Chagall', *Beaux Arts*, Nos. 73, No. 56, Paris, January 26, 1934; ABRAHAM EFROSS, 'Chagall', in *Grande Encyclopedie*, Vol. 61, Paris, 1934, pp. 787-788; JACQUES LASSAIGNE, 'Marc Chagall, peintre biblique', *Sept*, Juvisy, October 26, 1934; JACQUES MARITAIN, 'Eaux-fortes de Chagall pour la Bible', *Cahiers d'Art*, No. 4, Paris, 1934; A. M. HAMMACHER, *Marc Chagall*, Antwerp, 1935; ALFRED J. BARR, *Fantastic Art, Dada, Surrealism*, Museum of Modern Art, New York, 1936; ALEXANDER BENOIS, 'Exhibitions of the Instinctive Artists: exhibition at the Galerie des Beaux Arts, Paris' (Russian text), *Poslednija Novosti*, Paris, January 4, 1936; AMBROISE VOLLARD, *Recollections of a Picture Dealer*, Little Brown, Boston, 1936, French edition, Paris, 1937; HEINZ POLITZER, 'Marc Chagall, Versuch uber eine Gemeinschaft europaischer und judischer Kunst', *Judischer Almanach*, Prague, 1937; J. BEILINKY, 'Marc Chagall à l'Exposition d'Art sacré moderne', *Terre retrouvée*, No. 6, p. 5, Paris, December 15, 1938; PAUL FIERENS, 'Marc Chagall, peintre du bonheur', *Les Beaux Arts*, No. 28, Brussels, January 14, 1938; LUC HAESAERTS, 'Marc Chagall', *Combat*, Brussels, January 29, 1938; GEORGE MARLIER, 'Chagall et nous', *Nation Belge*, Brussels, February 1, 1938; STEPHANE REY, 'Marc Chagall', *XXeme Siècle*, Brussels, February 6, 1938; TRISTAN TZARA, 'Marc Chagall', *Cahiers d'Art*, 14, No. 5-10, Paris, 1939; CHRISTIAN ZERVOS, 'De la nécessité d'une importante exposition des peintures de Chagall', *Cahiers d'Art*, Nos. 5-10, Paris, 1939; ALEXANDER BENOIS, 'Exhibitions of Chagall' (Galleria Mai, Russian text), *Poslednija Novosti*, Paris, February 3, 1940; OSSIP BESKIN, 'Paintings and Graphic Arts of Byelorussia' (Russian text), *Iskustvo*, No. 6, Leningrad, 1940; MAX OSBORN, 'L'Art fantastique de Chagall', *De Telegraaf*, Amsterdam, March 5, 1940; RAYMOND ABEL, 'An Interview with Marc Chagall', *The League*, No. 1, New York, April 1942; M. FRASER, 'Marc Chagall', *New Republic*, New York, November 9, 1942; JACQUES GUENNE, 'Marc Chagall', *Art Vivant*, No. 72, Paris, 1942; M. ONTANON, 'Marc Chagall prépara un ballet *(Aleko)*', *Hoy*, No. 289, Mexico, 1942; RAISSA MARITAIN, *Marc Chagall*, Maison Française edition, New York, 1943; GEORGE SCHMIDT, 'Le Merveilleux dans l'art de Chagall, *Labyrinthe*, No. 2, Geneva, December 15, 1944; LIONELLO VENTURI, 'Chagall chez Pierre Matisse', *Spectateur des Arts*, 1, Paris, December 1944; E. LANGUI, 'Nieuw werk door Marc Chagall, in de USA geschapen, *Zontagspost*, No. 4, Brussels, 1945; LIONELLO VENTURI, *Marc Chagall*, Pierre Matisse, New York, 1945; LIONELLO VENTURI, *Painting and Painters*, Scribner's New York, 1945; Real Benoit, Visite à Marc Chagall, *Revue Dominicaine*, Montreal, January 1946; JEAN CASSOU, 'La Bible de Chagall', *Art et Style*, Paris, April 1, 1946; PAUL ELUARD, A Marc Chagall, poem in: *Le dur désir de durer*, Paris, 1946; PAUL ELUARD, Chagall, poem, *Poesie 46*, No. 29, Paris, January 1946; JAMES JOHNSON SWEENEY, *Marc Chagall*, Museum of Modern Art, New York, 1946; ANDRÉ WARNOD, 'Chagall est rentré à Paris', *Arts*, Paris, July 19, 1946; BRUNO ALFIERI, 'The Farmhouse of Chagall', *Camene*, N.s. II year, No. 11, Catania, 1948; MICHAEL AYRTON, *Chagall*, with notes by the artist (The Faber Gallery), London, 1948; WALDEMAR GEORGE, 'Chagall à Orgeval', *Arts*, No. 190, Paris, November 26, 1948; ALBERTO MORAVIA, 'Marc Chagall', *Occident*, Paris, January 1948; GIULIA VERONESI, 'Chagall', *Emporium*, Bergamo, July-August 1948; UMBRO APOLLONIO, *Chagall*, Venice, 1949; ROBERTO SALVINI, *Guide to Modern Art*, Florence, 1949; GUALTIERI DI SAN LAZZARO, *Painting in France, 1895-1945*, Harville, London, 1949; PETER J. POLLACK, 'Chagall and de Chirico: quick and dead', *Art Digest*, New York, January 1950; MICHEL RAGON, 'Marc Chagall, peintre de l'amour heureux – Chagall et Charlot', *NEF*, Christmas issue, 1950; LIONELLO VENTURI, *Pour comprendre la Peinture; de Giotto à Chagall*, Paris, 1950; LIONELLO VENTURI, 'Chagall et les Ames Mortes', *Derrière le miroir*, Nos. 27-28, Paris, 1950; PAOLO D'ANCONA, *Modigliani, Chagall, Soutine, Pascin: Aspects of Expressionism*, Milan, 1952; GISÈLE D'ASSAILLY, 'Visite à Chagall', *Le Figaro Littéraire*, Paris, March 1, 1952; FRANK ELGAR, 'Les Fables de La Fontaine', *Carrefour*, Paris, April 2, 1952; JACQUES LASSAIGNE, *Marc Chagall* (Les Trésors de la Peinture française), Geneva, 1952; R. SADOUL, 'Marc Chagall chez lui', *Pour l'Art*, No. 19, Lausanne, July-August 1952; AMBROISE VOLLARD, 'J'édite les Fables de La Fontaine et je choisis Chagall comme illustrateur', *Derrière le miroir*, Nos. 44-45, Paris, 1952; CHRISTIAN ZERVOS, *Cahiers d'Art*, No. 1, Paris, July 1952; LUIGI CARLUCCIO, 'Chagall and the Fantasy of the Theatre, *Il Dramma*, No. 183, Turin, June 15, 1953; YVAN CHRIST, *Chagall, Dessins* (Dessins de grands-maîtres peintres, VI), Deux Mondes Edition, Paris, 1953; SUZANNE TENAND, 'Gogol et Chagall, poètes d'une même terre', *Corps Diplomatique*, Paris, July, 1953; J. A. CARTIER, 'Paris vu par Chagall', *Combat*, Paris, June 15, 1954; ANDRÉ CHASTEL, 'Le bouquet parisien de Chagall, *Le Monde*, June 15, 1954; RAYMOND COGNIAT, 'Réalisme et Surréalisme', *Le Messager d'Athènes*, Athens, October 29, 1954; MAX LERNER, 'A visit with Marc Chagall', *New York Post*, New York, August 1954; FRANZ MEYER, 'Picasso and Chagall', *Neue Zürcher Zeitung*, Zurich, June 30, 1954; CLAUDE ROGER-MARX, 'L'enfer de Picasso et le ciel de Chagall, *Figaro Littéraire*, Paris, June 19, 1954; LIONELLO VENTURI, 'Paris de Marc Chagall', *Derrière le Miroir*, Nos. 66-68,

Paris, 1954; FRANCO RUSSOLI, 'Mercury runs through the paintings of Chagall' *Settimo Giorno*, Milan, April 7, 1955; ROGER HAUERT and ANDRÉ VERDET, *Marc Chagall* (Les grands peintres) ed. Rene Kister, Geneva, 1956; Jacques Lassaigne 'Chagall en Grèce', *Prisme des Arts*, No. 1, Paris, March 15, 1956; MARIA NETTER 'Marc Chagall: Works of the last 25 years', *Werk*, Winterthur, 1956; GOD[?] REMSZHARDT, *Marc Chagall*, ed. Buchheim, Feldafing, 1956; MEYER-SCHAPIRO 'Chagall's Vision of the Old Testament', *Harper's Bazaar*, New York, Novembe[r] 1956; GEORG SCHMIDT, 'Inaugural address at the Exhibition of Marc Chagall a[t] the Kunsthalle in Basel', Basel, 1956; LIONELLO VENTURI, *Marc Chagall* (Collection[s] Le Gout de Nôtre Temps), Geneva, 1956; GINGI BECK, 'Hommage à Chagall' *National Zeitung*, No. 306, Basel, July 7, 1957; JACQUES LASSAIGNE, *Chagall* Maeght Edition, Paris, 1957; JACQUES LASSAIGNE, 'Chagall aujourd'hui, *La Pensé[e] Française*, No. 4, Paris, February 15, 1957; JACQUES LASSAIGNE, 'L'oeuvre récente d[e] Marc Chagall', *XXe siècle*, n.s., No. 9, Paris, June 1957; GUIDO LODOVICO LUZZATTO 'La Bible de Chagall', *Bulletin de la Communauté Israelite de Milan*, Apri[l] 1957; FRANZ MEYER, *Marc Chagall: Das graphische Werk*, biography and biblio[g]raphy by Hans Bolliger, ed. Gert Hatje, Stuttgart, 1957; FRANZ MEYER, 'Mar[c] Chagall, "Meiner Braut gewidmet"', *Mitteilungen*, Art Museum, Berne, Februar[y] 12, 1957; A. PINTO, 'Marc Chagall', *Goya*, No. 16, Madrid, February 1957, wit[h] illustrations; WERNER SCHMALENBACH, *Chagall* (Die Kunstreihe in Farben), Deutsch[e] Buchgemeinschaft, Berlin, 1957; LIONELLO VENTURI, 'Marc Chagall', *Les Beaux Arts*, Brussels, 1957; SANDRO VOLTA, 'Chagall's Seventy Years', *Lo Smeraldo*, X[I] year, No. 5, Milan, September 30, 1957; LOUIS ARAGON, Marc Chagall et la lumièr[e] de l'amour, poem, *Les Lettres Françaises*, Paris, February 6, 1958; G. BESSON, *Mar[c] Chagall* (Le Musée chez soi), ed. Braun, Paris, 1958; ALBERTO BOALTO, 'Mar[c] Chagall', *Giornale del mattino*, Florence, March 27, 1958; ELISA DEBENEDETT[I] 'Essay on the Interpretation of Chagall's Green Violinist', *Commentari*, IX October-December 1958; G. POGGIOLI, 'Chagall, graveur', *Cahiers du Sud*, Mar[s]eille, April 7, 1958; LOUIS ARAGON, *Triumph of Chagall*, poem, *Les Lettres Fran[ç]aises*, No. 779, Paris, June 25-July 1, 1959; GEORGES BOUDAILLE, 'L'Oeuvre Intégral de M. Chagall', *Les Lettres Françaises*, No. 777, Paris, June 11, 1959 MARCEL BRION, *Chagall*, ed. Somogy, Paris, 1959; RAYMOND CHARMET, 'Cinquant[e] ans de peinture de Marc Chagall', *Arts*, No. 726, Paris, June 10, 1959; WALDEMA[R] GEORGE, *Les artistes juifs et l'Ecole de Paris*, The World Jewish Conference Edition[s] Algiers, 1959; JEAN GRENIER, 'Marc Chagall', *L'Oeil*, No. 52, Paris, April 1959 FRANÇOIS MATHEY, *Marc Chagall; 1909-1918; 1918-1939* (Petite Encyclopedie d[e] l'Art, 27-28), ed. F. Hazan, Paris, 1959; FRANZ MEYER, 'Chagall au Musée des Art[s] Décoratifs, *XXe Siècle*, No. 4, Paris, June 1959; F. RIGAMONTE, 'Chagall ha[s] become a peaceful man', *Illustrazione Italiana*, Year 86, No. 2, Milan 1959 PHILIPPE SOUPAULT, *Ode à Marc Chagall*, unpublished poem, *L'Essai*, 1, No. 1 Liège, 1959; A. ADAMOV, 'Monsieur Chagall – qui êtes-vous?'; DOC, Monthl[y] Documents published by *Travail et Culture*, No. 5, Paris, April 1960; *Chagal[l] Lithographs*, preface by Marc Chagall, text by Julien Cain, notes by Fernan[d] Mourlot, ed. André Sauret, Paris, 1960; FRANZ MEYER, 'Chagall's Pariser Zyklus' *Jahrbuch der Hamburger Kunstsammlungen*, Hamburg, 1960; ALFRED WERNE[R] 'Marc Chagall's self-revelation', *Reconstructionist*, 26, No. 7, New York, May 1[3] 1960; GISÈLE D'ASSAILLY, 'Les vitraux de Chagall', *Aux Ecoutes du Monde*, June 3[0] 1961; JEAN BURET, 'Chagall. Vitraux pour Jerusalem', *Les Lettres Françaises*, Pari[s] June 22, 1961; MAURICE CARR, 'Chagall Windows for Hadassah on Show at Louvr[e] Museum', *The Jerusalem Post Weekly*, Jerusalem, June 23, 1961; JEAN ALBERT CAR[-]TIER, 'Chez Marc Chagall', *Les Nouvelles Littéraires*, No. 1768, Paris, July 20, 1961 AUDREY DAVIS, 'Chagall at Vence', *The Guardian*, Manchester, June 1, 1961 JACQUES DUPONT, 'Un vitrail de Marc Chagall à la Cathédrale de Metz', *Cahiers d[e] la Ceramique, du Verre et des Arts du Feu*, Sèvres (S.O.) No. 19, 1961; PIERRE GASCA[R] 'Voyage dans le Vitrail. A propos de l'Exposition Vitraux pour Jerusalem d[e] Marc Chagall', *Le Figaro Littéraire*, June 24, 1961; MANUEL GASSER, *Selbstbildnisse* Kinder-Verlag, Munich, 1961; EMILY GENAUER, 'Chagall's crowning achievement' *Herald Tribune*, July 2, 1961; PIERRE LEUZINGER, 'Malraux fait construire pou[r] Chagall dans le Jardin des Tuileries', *Tribune de Genève*, Geneva, June 24, 1961 ALBERTO ONGARO, 'The Bible of Glass' (exhibition, Musée des Arts Décoratifs) *L'Europeo*, XVII, No. 34, Milan-Rome, 1961; CLAUDE ROGER-MARX, 'Les Vitrau[x] de Chagall', *La Revue de Paris*, Paris, August, 1961; RENE DE SOLIER, 'Chagall' *Nouvelle Revue Française*, No. 105, September 1961; 'Marc Chagall in a Ne[w] Light', *The Times*, London, July 17, 1961; SANDRO VOLTA, 'Twelve Large Win[-]dows by Marc Chagall in a Pavilion in the Garden of the Louvre', *La Stampa* Turin, August 1, 1961; FRANZ MEYER, *Marc Chagall*, ed. Il Saggiatore, Milan, 1962 BELLA CHAGALL, *Lighted Lamps*, New York, 1962; MAX DIMONT, *Jews, God an[d] History*, New York, 1962; JEAN LEYMARIE, *Marc Chagall: Vitraux pour Jerusale[m]* Monte Carlo, ed. André Sauret, 1962; JACQUES DAMASE, *Marc Chagall*, Verviers 1963; CARL JUNG and M. L. VON FRANZ, *Man and his Symbols*, London, 1964; *Mar[c] Chagall et les vitraux de Metz*, catalogue of the exhibition at the Musée des Beaux-Arts in Rouen, Rouen, 1964; JEAN CASSOU, *Marc Chagall*, New York, 1965; RAYMON[D] COGNIAT, *Chagall*, Milan, 1965; JACQUES LASSAIGNE, *Le plafond de l'Opera d[e] Paris par Marc Chagall*, Monte Carlo, ed. André Sauret, 1965; MARTIN BUBER *Hasidism and Modern Man*, New York, 1966; JEAN LEYMARIE, *Marc Chagall monotypes 1961-1965*, with a catalogue by Gerard Cramer, Geneva, 1966; JOH[N] MOLLESON, 'Chagall, at the Met: God, Mozart, Color', *New York Herald Tribune* February 20, 1966; ANDRÉ PARINAUD, 'Chagall', *Club d'Art Bordos*, Paris, 1966 HERMAN E. KRAWITZ, 'An Introduction to the Metropolitan Opera House, Lincol[n] Center Plaza', *Saturday Review*, New York, 1967; Hommage à Marc Chagall oeuvres de 1947-1967, catalogue of the exhibition at the Maeght Foundation Maeght Edition, St Paul de Vence, 1967; FERNAND MOURLOT, *Chagall Lithographs* Paris, 1960-1967; ROY MCMULLEN and IZIS BIDERMANAS, *The World of Marc Chagall* London, 1968, Italian edition *Marc Chagall e il suo mondo*, Milan, 1968.